RARY

Successful Sketching

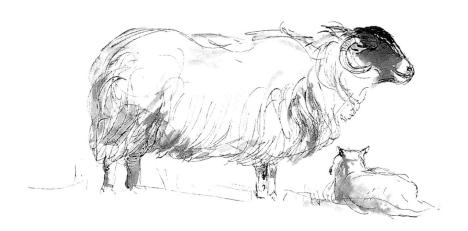

Discarded by the Blanchester Public Library

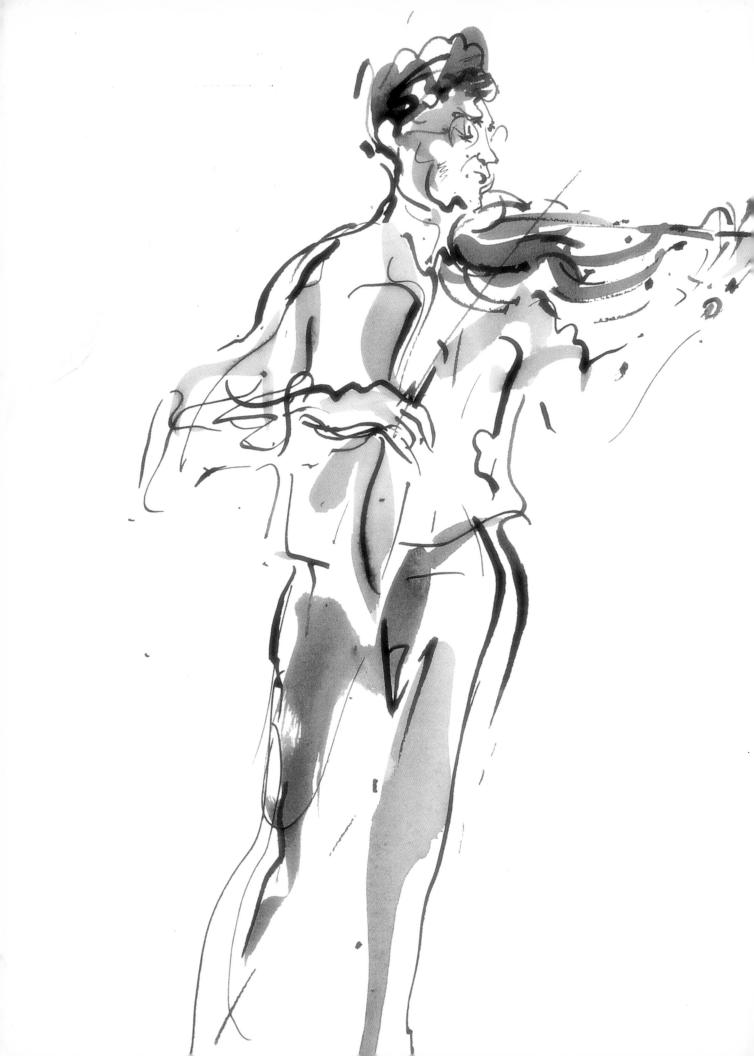

Successful Sketching

VALERIE WIFFEN

Sterling Publishing Co., Inc. New York A Sterling/Silver Book

A QUARTO BOOK

Library of Congress Cataloging-in-Publication Data is available upon request

Published by Sterling Publishing Co., Inc 387 Park Avenue South, New York, NY 10016-8810

Distributed in Canada by Sterling Publishing c/o Candian Manda Group One Atlantic Avenue, Suite 105 Toronto, Ontario, Canada M6K 3E7

Copyright © 1998, 2001 Quarto Inc First paperback edition 2001

All rights reserved. No part of this publication may be reproduced, stored in a retrieval system, or transmitted, in any form or by any means, electronic, mechanical, photocopying, recording, or otherwise, without the permission of the copyright holder.

This book was designed and produced by Quarto Publishing plc, The Old Brewery 6 Blundell Street, London N7 6BH

Project editor Michelle Pickering
Text editor Ian Kearey
Senior art editor Elizabeth Healey
Designer Caroline Hill
Illustrators Ian Fellows, Nick Hersey,
Julie Joubinaux, Debra McFarlane,
Jody Raynes
Photographers Colin Bowling,
Martin Norris
Art director Moira Clinch

Typeset by Central Southern Typesetters, Eastbourne, UK Manufactured by Pica Color Separation Overseas Pte Ltd, Singapore Printed by Star Standard Industries (Pte) Ltd, Singapore

Assistant art director Penny Cobb

ISBN 0-8069-2437-3 (hardcover) ISBN 0-8069-2350-4 (paperback)

Page 1: Sidney Kay, Sheep at Croftnuisk, Pen and wash Page 2: Ian Ribbons, Violinist, Pen and color wash

Contents

Introduction 6 How to Use This Book 9

Chapter I TOOLS AND MATERIALS 10

Paper 12 Charcoal and Carrés 14 Pencil and Graphite 16 Pen and Ink 18

Brush Drawing and Washes 20 Pastels 22 Colored and Aquarelle Pencils 24

Chapter 2 PLANNING AND DRAWING 26

• Viewpoint and Size 28 • Format and Focus 30

Design in Two and Three Dimensions 32

Still Life: Graphite 34

Townscape: Charcoal 38

Gallery 42

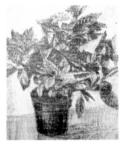

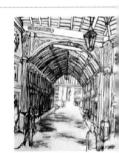

Form and Space 44

Townscape: Carré 46

Portrait: Wash 50

Gallery 54

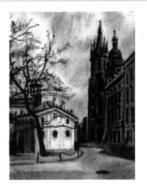

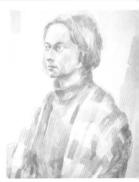

Tone 56

Still Life: Pen and Ink 58

Landscape: Pencil 62

Gallery 66

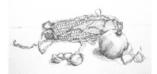

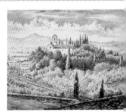

Color 68

Still Life: Aquarelle Pencils 70

Portrait: Oil Pastel 74

Gallery 78

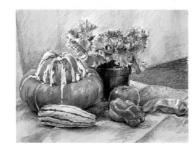

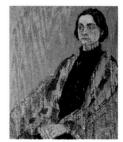

Pattern and Texture 80

Still Life: Pastel 82

Landscape: Pastel 86

Gallery 90

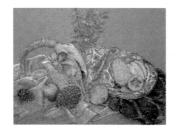

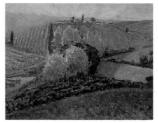

Line and Movement 92

Landscape: Pastel 94

Figures: Pen and Wash 98

Gallery 102

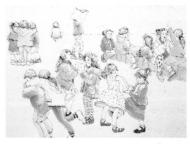

Chapter 3 DEVELOPING A STYLE 104

Introduction 106

Still Life 108

Townscape 114

Portrait 120

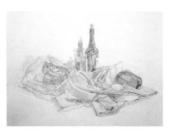

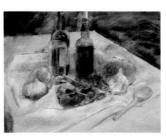

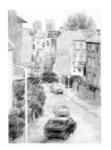

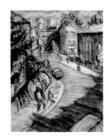

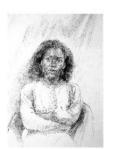

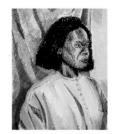

Introduction

The best way to raise the quality of your drawing is to learn the simple skill of looking properly at what you see. Your everyday vision is specific, and concerned with gathering particular information, leaving most other things unseen. Looking for drawing is a different matter, and requires a penetrating gaze to gather as much information as possible about the subject that you want to draw.

Taking ideas from what you see is a much easier way to acquire drawing skills than making up a picture. Working from an inner vision, while it has expressive possibilities, does not offer a way to evaluate your progress. Reality is a benchmark that enables you to make continual comparisons with your inspiration, and, by picking up on disasters in the early stages, to improve your end results. Drawing requires observation both to gather information and to evaluate your rendering of it, and drawing without assessing each mark as you go is the equivalent of driving without looking at the road; a big crash can be expected at any time!

A four-step process

The art of drawing is essentially a practical task, and your work will improve rapidly if you adopt the right practice. The best method for drawing from observation is simple, and involves a four-step process. The first step is to use a searching look, not just a brief glance, to gather information.

Scan broadly, just as you would for fast driving, to look at both the element you are dealing with, and the relationship it has to the whole scheme of things. Without this overview, you will work on a series of tiny details, and emerge with a fragmentary result that lacks cohesion.

Next, you need to make a choice about what to show as a selection from the wealth of information you have just taken in. Beginners stumble here, wondering how to make a suitable mark, but the real decision concerns what to represent — you are not a camera that

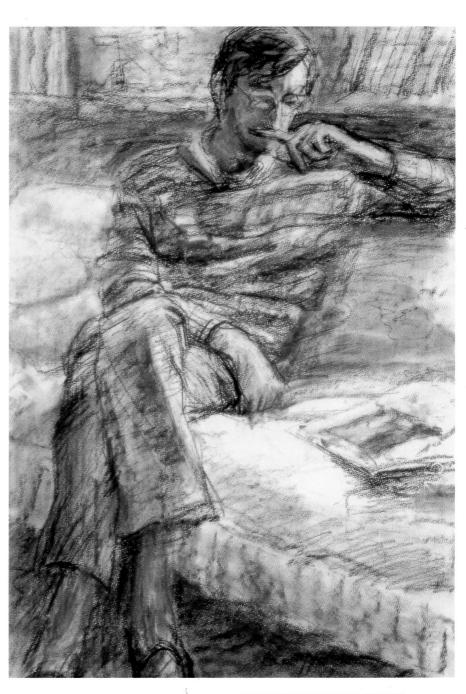

MIKE READING

TONY COOMBS

A rich, strongly toned medium is a good choice for a large drawing that will be viewed from a distance. Subtle tones are created by softening the drawn marks, making an evocative image that conveys the thoughtful mood of the sitter. (Charcoal)

produces a mechanical, indiscriminate selection. Your drawing is all your own, and relies on nobody else for content, so why not choose to show what appeals to you, what you consider important, and the elements you find most fascinating? When you have decided what your preoccupations are, finding the visual language to express them follows. This key stage is the cradle of your individual identity as an artist, because it is your free and expressive choice that is unique, and will give your drawing a personal style, without any further effort.

The third stage is a critical one. So far, you have looked with care and chosen with courage, but now you need to evaluate with insight. If you try to monitor your progress from a drawing distance, your proximity

and involvement with the current work can impede your evaluation. By looking from a little farther away, so that you can compare the whole drawing to your subject, you will have an overview — this will show how close you are to capturing the whole effect, and where any discrepancies are. Remember to acknowledge your successes: you need to note what has worked well and can be relied on.

Step four follows on from your assessment at the last stage. If everything looks fine, continue to add and develop new aspects, building on work that you have confirmed as a sure foundation. If you notice anything requiring correction or amendment at step three, then this stage will be devoted to dealing with it. Provided that you go no farther until you have set any problems to rights, you are safe from catastrophe. You will only end up with a complete failure if you forget to assess continually and carry on, assuming all is well, and realize far too late that a major discrepancy has passed uncorrected, or a small misrepresentation has grown. Save disappointment by being vigilant at step three, and thorough at step four.

Choosing your medium

When you have decided what to draw, you need to select a medium that expresses your choice. Try as many media as possible, and familiarize yourself with their characteristics. Some are appropriate for speed or convenience, others for impact, versatility, delicacy, or expressiveness. Those that make big marks easily, charcoal for example, are good for

SHEARING SHEEP

KEITH BOWEN

Repeated actions offer the chance to make a composite drawing over a period of time, by gleaning additional material each time a similar pose is struck. Broad handling, with simple shapes blocked in and detail kept to a minimum, is the best approach to accommodate minor changes in the figure position, and many sheep will be sheared of similar fleece. (Pastel)

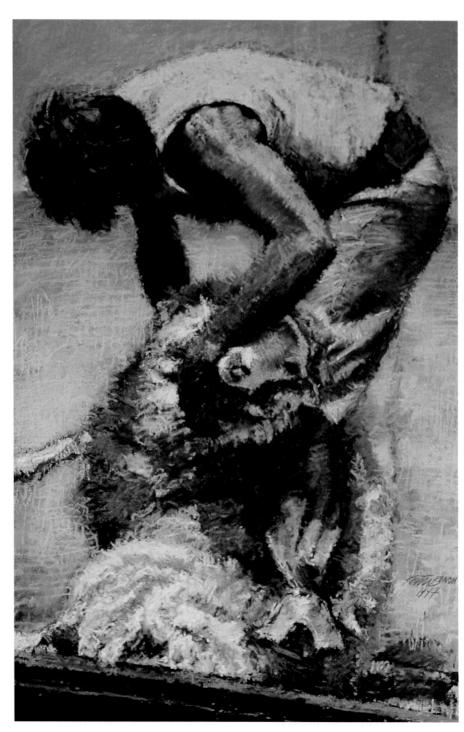

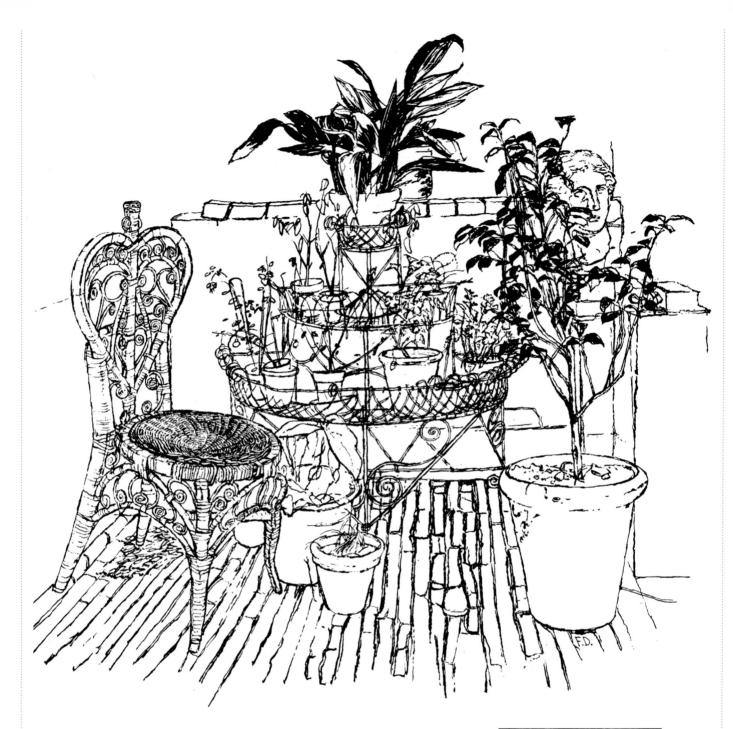

large, quick work. Those that express a wide range of subtleties but make linear marks, like pen and ink, are best used when more time is available to build up effects. Media that give a rich tonality, such as carré pastels, can be seen at a distance. Those with less tonal depth, pencil for instance, will register best from nearby. Some media, like colored pencils, are light and clean to use, and lend themselves well to location work. Others that create dust, like charcoal or pastel, are unsuitable for use in some situations, but have the advantages of speed and beauty. Each medium has different expressive potential, and this book features a range of drawing demonstrations that link each medium to an appopriate subject. Together with the many gallery examples, these show various types of drawing to give you an insight into suitable choices for your own work.

IARDINIERE

FRED DUBERY

Making drawings with line alone requires practice, because without the help of tone, describing the three-dimensional nature of your subject is more difficult. Persevere, because when the line is truly descriptive of the forms and spaces you have observed, a beautifully fine and decorative effect, with the charm of economy, can be achieved. (Pen and ink)

How to Use This Book

This book is divided into three chapters. The first gives information on media and equipment.

The second describes twelve projects in detail, to demonstrate the use of particular media. The third looks at personal interpretations by comparing the work of three pairs of artists.

Each section in chapter two starts with an introduction about its focal theme. This will lead you into the subject or introduce a new technique. An example of a completed drawing is shown, and the author explains how it has been created.

Tone

Subsequence can be surfaced that focus any form a light source.

Tone

To reset to develop methods the behaling to highlighting years

surfacing to the signs of source in such as the words. As and when the surface is the surface in the surface is the surface in the surface in the surface in the surface is the surface in the surface in the surface in the surface in the surface is the surface in the surf

Drawings are analyzed to illustrate the principle under discussion

Swatches or diagrams highlight the subject of each section

Introductory analysis of the subject

List of tools and _ materials you will need

Thumbnail sketch shows the basic structure of the drawing Townscape:
Carré

APRIL SURCE Visige on a paragrama or designation or designation

Step-by-step photographs show how the drawing is built up

Finished drawing shows how all the layers have built up to complete the composition

Within each section there are two step-bystep demonstrations by different artists. These demonstrations take you through each of the stages that the artist has used to create the whole composition. At each stage you can see exactly what he or she has added to the drawing and how the picture is gradually building up.

Separate pictures show exactly what has been added to the drawing at each particular stage

ON FILLOWS

Check for disconduct radius by helf-shory
year cert and period through star link
For a knowled crown to lift the shory from
not more strong hour, then for the drawn
not more strong hour, then for the drawn

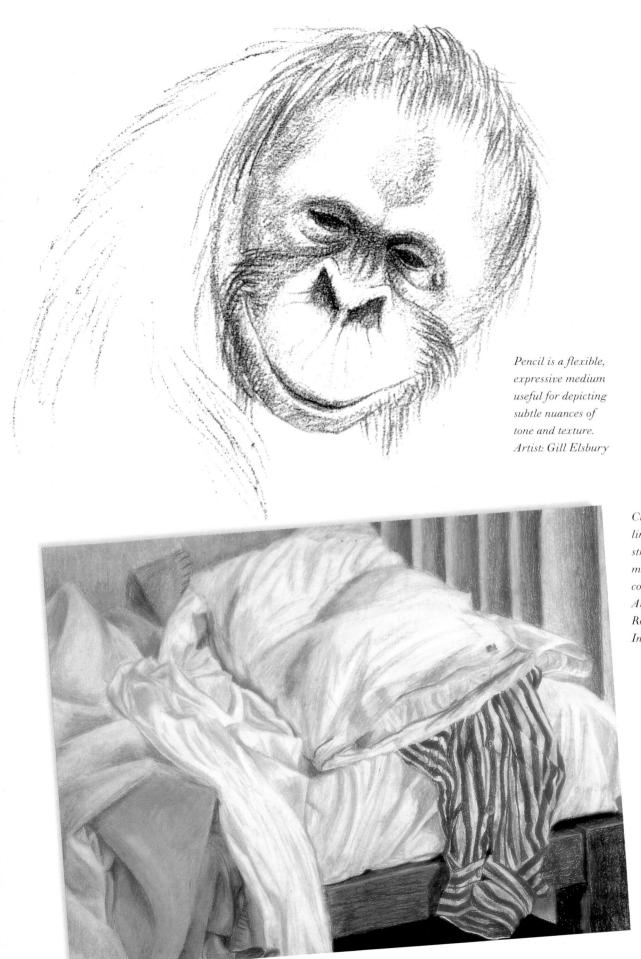

Crisply defined linear folds and stripes are easily managed with colored pencils.
Artist: Beamish/Roehampton
Institute of Art

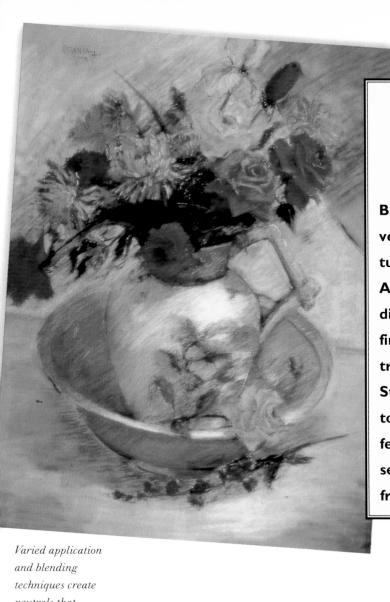

Tools and Materials

Buying lots of materials and equipment is very tempting, but rash purchases often turn out to be unsuitable and little used. Avoid unnecessary expense and disappointment by buying moderately at first – think of any new material as "on trial" until you have experimented with it. Start simply with a medium that appeals to you, phasing in others gradually as you feel the need to broaden your range, or to see your drawing in the new light that a fresh approach offers.

Varied application and blending techniques create neutrals that contrast with the glowing colors of the pastel shades.

Artist: Urania Christy Tarbet

Hatching, dot, and stipple techniques add variety to brush drawing in ink. Artist: Ian Ribbons

Paper

Drawing is all about making marks, so in theory any markable surface can be

used. Paper is the usual choice because it is durable if kept dry and easily portable, and offers a variety of colors and surface finishes. Other supports may require priming, or are too heavy for comfort, or degrade over time, but wood and card are reasonable alternatives and are worth considering if a project calls for exceptional strength or bulk.

ODERN DRAWING PAPER is made from plant fibers; the cheapest sort, produced from wood pulp, is unsuitable for anything other than quick sketches and brief studies. It has a high acid content that causes it to deteriorate quickly and become yellow and brittle with age. All unclassified

drawing paper is acidic unless it is specifically stated to be acid-free; using acidic paper is a bad investment of the time and care you put into your work.

Watercolor papers

The best choice is watercolor paper, which can be matched to the media

PAPER SURFACES AND WEIGHTS

Paper mills produce numerous surface variations, so try out samples until you find what you like. For easier stretching, use a minimum weight of 115 lb (250 gsm). Hot-pressed paper is best for pen work, but other media can slide on this, so try cold-pressed, or not, paper when using pencils, charcoal, or soft pastels. Washes look dull on hot-pressed paper, so use a cold-pressed or rough surface for them.

you intend to use. It is manufactured with three different types of surface. Hot-pressed, or HP, papers are smooth and are ideal for fine work, particularly with pen and ink. They are less suitable for color washes, because the flat surface makes colors appear dull. Cold-pressed paper, also known as not (for not hot-pressed), has a lightly textured surface that takes broken effects well, but can be filled easily with solid color; it is excellent for charcoal and pastel work. Paper that retains the imprint of the felt spacing blankets used in its manufacture has a pronounced surface texture and is classified as rough. This surface makes drawing in fine media difficult, but shows washes to advantage, because the white surface reflects light and gives colors extra brilliance.

TORING STATE

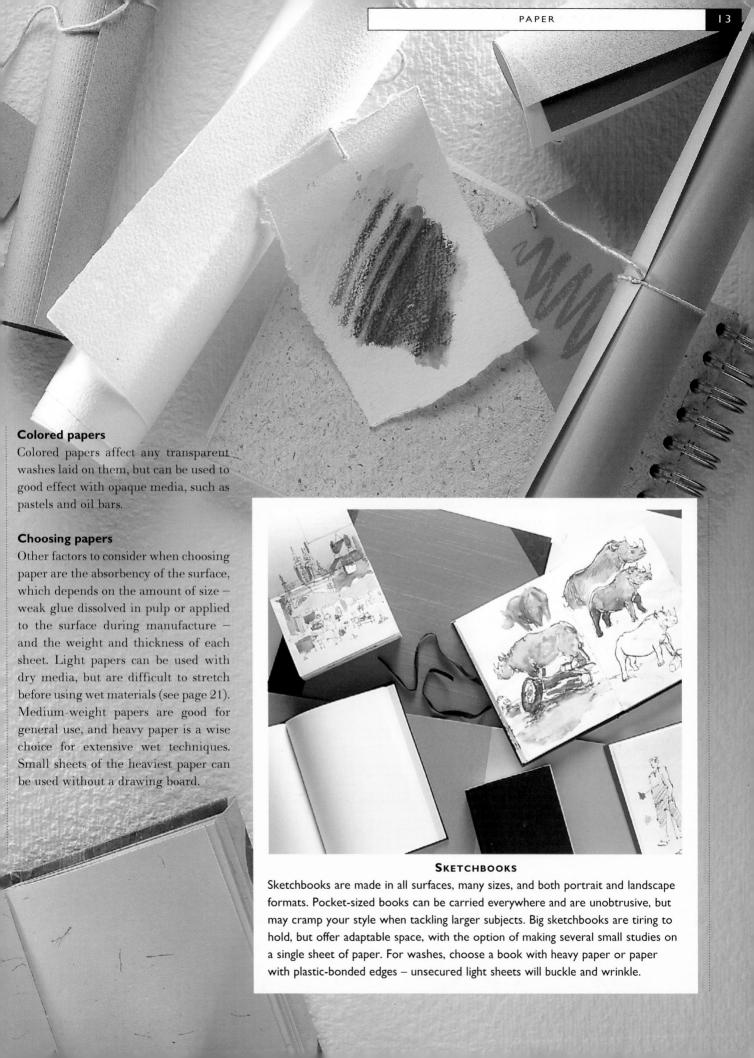

Charcoal The simple, burned to drawing is produced to and Carrés

The simple, burned twig of charcoal used for drawing is produced by smoldering wood,

usually willow but sometimes olive,

slowly in reduced-oxygen conditions. The result is a stick charred to an even, sooty blackness, that makes a smooth, rich drawing mark. Depending on the grade and the wood used, there are variations in color, between silver, brownish, and sooty black.

A LIHOUGH A FINE edge, for making a narrow mark, can be achieved by wearing down the point of a stick, charcoal responds best to broad use. Dark tone and shading are fast and easy to produce, so you can draw tonally with facility; and if you draw tone together with line, proportions are easy to gauge and dimensions can be seen clearly.

Stick charcoal

Charcoal is usually sold in boxed bundles, and is graded fine, medium, and thick for width, and soft, medium, and hard for consistency. Block charcoal and scene painters' extra-large sticks are good for oversize work, but if you use the side as well as the tip, even small sticks create broad areas of tone. Don't be afraid to work boldly, because stick marks can be completely removed with a kneaded eraser.

Compressed charcoal

Compressed charcoal is put through a manufacturing process that compresses the carbon and makes it dense black, producing even-textured crayons. Kneaded erasers do not remove all of the surface material, as they do with stick charcoal, so make delicate marks until you are sure of your layout. Compressed charcoal is also available mixed with chalk to make shades of gray; you can use white chalk to make your own mixtures. For pale shades, draw with chalk first and work the compressed charcoal into it gradually, because it is easy to over-darken.

If alterations are required when working in carrés or charcoal, the soft, tacky composition of a kneaded eraser is ideal. Knead the eraser if its dust-loaded surface loses adhesion.

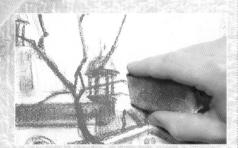

Tap the surface to lift off the loose dust—this is an alternative to softening with a stump or wiper—then erase any residue.

Charcoal pencils

Charcoal pencils are a wood-cased, pencil version of compressed charcoal. They are often graded hard, medium, and soft, although some manufacturers adopt the same categories as graphite pencils (see page 16). Charcoal pencil marks are erasable, but traces remain, so start tentatively.

Carrés

Carrés, or hard pastels, are classed with this group of media. Traditionally, these are available in black, white, and two earth shades: bistre, a dark brown, and sanguine, a terracotta. They are lightly baked into a square-sided stick form, and have a density and crispness of mark similar to charcoal pencils. This addition of a limited color choice makes them an ideal progression from monotone and a simple introduction to drawing in color.

Fixing dusty media

Fixative is a mixture of resin and spirit solution, available in aerosols or bottles, which is used to secure the pigments of soft media – those that rub off or are smudged when they are touched accidentally. Keep applications of fixative light, particularly on soft pastels, because these are easily dimmed.

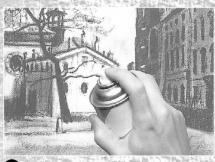

When using an aerosol fixative, never inhale the spray. Avoid breathing it by spraying out of doors, or by leaving the room until the air clears.

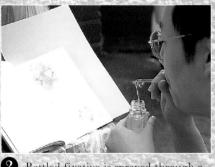

2 Bottled fixative is sprayed through a mouth atomizer. It can also be used to spray plain water, to settle dusty media between drawing stages.

Pencil Pencil is the perfect flexible medium, creating a wide range of expressive marks. The core, commonly called the lead, is and Graphite

made of graphite

with clay and lightly baked for firmness. Pencils with more clay than graphite in their composition, graded H, for "hard," are made for technical drawing and are unsuitable for artwork. Pencils with more graphite in their core are graded B, for "black;" use these or the grade marked F, for "fine."

NOTHER GRADE of pencil is HB. These are for writing and may be too hard for drawing, but try out any you have; some have the same combination of blackness and firmness as an F, and can be used if a fine point is needed. Use the 2B grade for general work, and try up to 6B for softer, blacker marks. 9B is the softest of all, but keep your hand high off the paper when using it, so as not to smudge the marks. Clutch pencils, that grip a detachable lead, are convenient, but the softest grades are not available in this form and you may have difficulty in purchasing a range of other grades. When working with wide differences in tonality, the darkest grades tend to dominate, so work in a close range.

Holding the pencil

Unlike writing, when your hand rests on the paper, a drawing grip should enable you to make wide movements and keep your hand off the paper, to avoid smudging. Practice making marks on scrap paper until you feel comfortable holding a pencil lightly, grasping it well away from the point. Always work with a sharp pencil; blunt points make uncontrolled marks. For faster, broader marks try using solid graphite sticks, with the same composition and grades as pencils. Use the side of the stick for broken or rapid covering, after scraping off any protective lacquer.

Graphite powder

Graphite powder can be made by scraping down a graphite stick with a sharp knife. Applying the powder with a stump, a pencil-shaped tool of rolled soft paper, produces a subtle mark that you can use in preference to rubbing with a finger, which makes an unspecified, vague mark.

Erasing

Pencil and graphite marks can be erased using a firm, white, plastic eraser; avoid gritty types that abrade the drawing surface. When you have finished a drawing in soft grades of pencil, fix it lightly (see page 15) or h will rub, particularly in a sketchbook that may be carried about frequently.

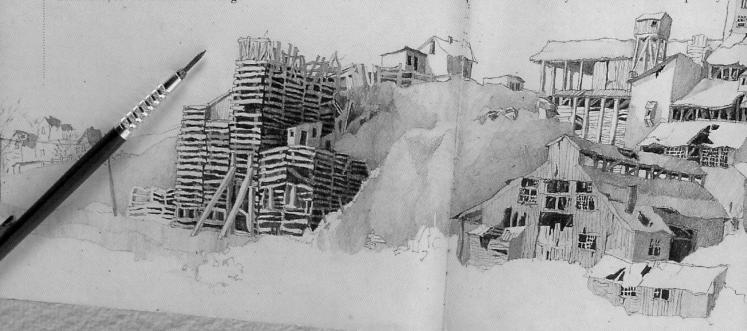

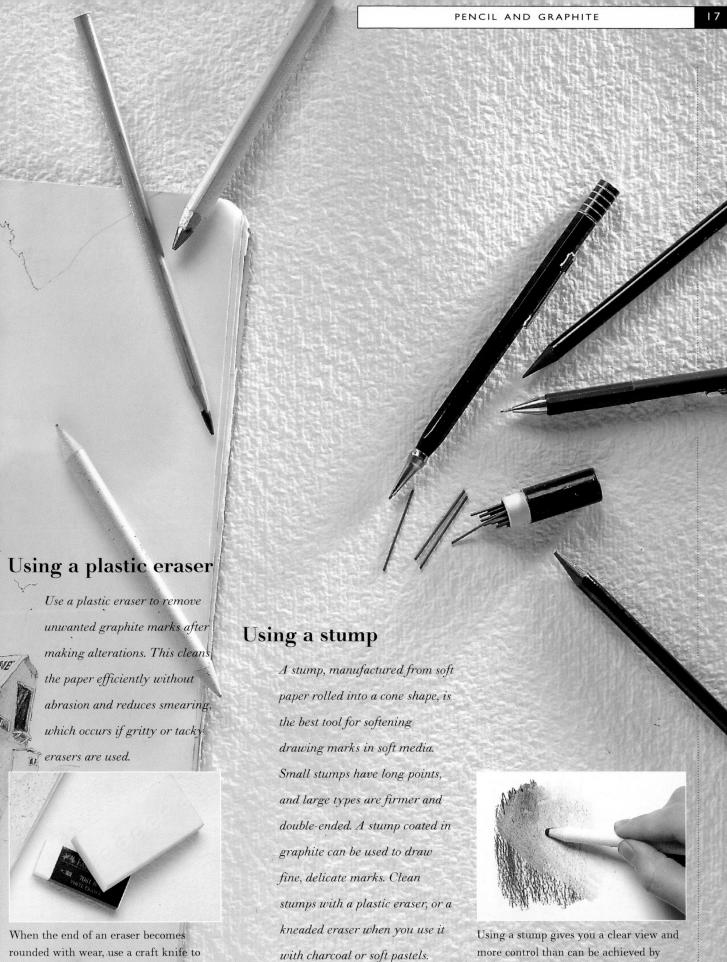

rubbing with your fingertip.

rounded with wear, use a craft knife to trim a sharp edge for precise work.

Pen Any pointed instrument dipped in ink, such as a sharp stick, will draw. This is fun for big, loose work, but for fine marks and sustained ink flow, and Ink

flow, use a dip pen or technical pen.

These have different characteristics, so

experiment on scrap paper first, and then choose the type that suits your purpose best.

ECHNICAL PENS ARE convenient to use, and the clean, light, disposable types are perfect when traveling. Buying a refillable technical pen with interchangeable nibs saves money in the long term, but make sure you choose one with a well-designed mechanism, as some can clog easily. Technical pens lend themselves to fast work, but the drawback is that their tubular nibs make an unvarying mark, useful for technical drawing but not for art. Use your ingenuity, and practice making hatched, dotted, or stippled marks that enliven the mechanical appearance of the lines; adopt the same approach when working with rollerball or other mechanical pens.

Dip pens

For sustained drawing, try using a dip pen. A penholder with a long, cut-steel nib, such as a steel crow-quill, is flexible and responds to pressure; avoid shorter writing nibs and fountain pens, where the broad tip gives little possibility of variation. Pens cut from rigid or brittle materials like quills, reeds, or bamboo can be used very expressively. They

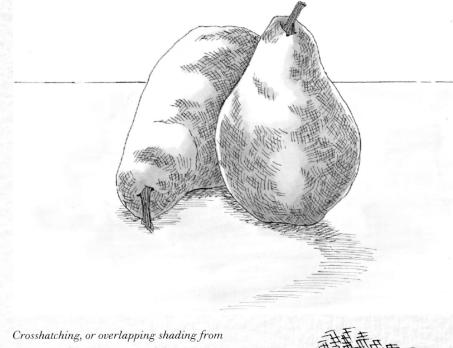

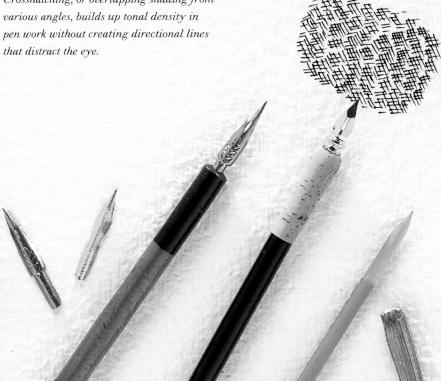

offer several mark-making surfaces: the broad nib for wide marks, the side for narrow ones, and the back of the tip for fine dots and lines.

Inks

Traditional, lightfast drawing and calligraphic inks are available in black and a limited range of colors, but many modern inks, with a much larger range of colors, are dye-based and not permanent, making them unsatisfactory for substantial work; acrylic inks fade less. Unlike ink sticks, powder and water-soluble inks, waterproof ink has a varnish content that fixes it when dry, and subsequent applications cannot disturb it. Use only distilled water to dilute it, or it will curdle.

Inks stain paper permanently, so dilute them to a pale tint or use dot and stipple techniques if you want to make a cautious start. Use gouache paint to white out unwanted marks, or scrape them off the paper carefully, using a sharp knife; both these techniques affect the surface, so use them only at the end of your work.

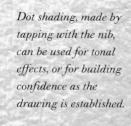

Brush Drawing

Brushes that point

well can be used to make any man, some sweep of wash. They are the perfect drawing tool for well can be used to make any mark, from a fine line to a

Washes effects fast. For fine drawing, use a

capturing both broad and subtle

large, springy soft-hair brush that will stay flexible when wet; using a delicate touch, it is possible to make small marks with big brushes, but making marks with a small brush is a laborious task.

ID-PRICED SYNTHETIC-HAIR brushes are reliable predictable; if they lack character, they are useful and long-lasting. Natural hair is highly priced, with sable brushes being the most expensive; this should only be considered if you do a lot of wash drawing, as the outlay is not justified for occasional use. Cheaper alternatives are available, such as

Oriental brushes, which use brown weasel hair with a good spring. These are supplied stiffened with protective starch, but if in doubt ask your art-store dealer about their qualities. Brushes with no spring, or which do not come to a point, will not draw a controlled line.

Wash brushes do not have any spring and are used for flooding large areas with color quickly. A large, traditional, squirrel-hair mop brush may seem costly, but the Oriental alternative of white hair, usually goat, is inexpensive and serviceable.

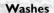

Washes can be made by diluting any water-based paint or ink. Those made with watercolors or waterproof ink will be transparent, while dilutions of gouache, acrylics, and other opaque media are opalescent or semi-opaque. Mix plenty of wash before drawing; having too much is preferable to running out in the middle of a large area.

Until you gain confidence in wash drawing, begin by making the wash, and add the drawing after. This allows you to work lightly at the start, and gives you the chance to make adjustments. A second, stronger wash and later drawing will render the first, uncorrected wash unnoticeable, but make sure you wash freshly each time;

Washes spread evenly, but with undefined edges, as they disperse on damp paper.

To create defined edges, wet the paper only to the required limit of the color.

reiteration loses crispness, and each application excludes more white paper. Two pale washes overlaid make a darker tone than you might expect, so practice laying washes on scrap paper beforehand until you are used to gauging their strength. Flooding and blotting washes can save some disasters, but only washes laid on wet paper and removed at once stand a chance of leaving no stain.

A good detail brush points well when wet, liners are blunt, and mops are soft-edged.

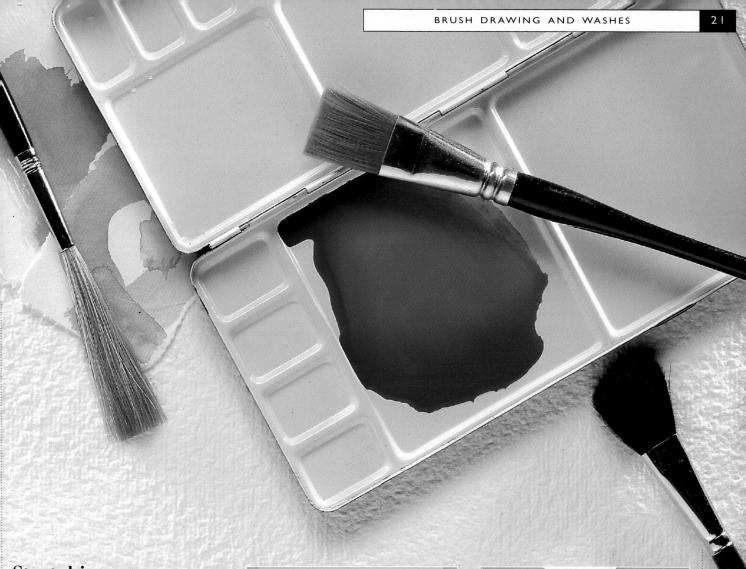

Stretching paper

When using any wet medium, such as ink or watercolor washes, stretch all but the heaviest papers on a thick wooden board with a mat surface, to prevent the paper from buckling as soon as it "relaxes" when dampened by the medium. Use gummed paper tape to hold it in place, because self-adhesive tape does not bond to wet surfaces.

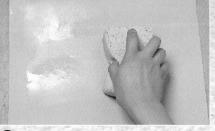

① Dampen lightweight paper using a sponge and clean water. Immerse heavierweight paper briefly.

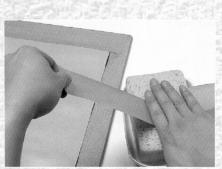

2 Cut strips of gummed paper tape, allowing for overlaps at the corners, and moisten with a damp sponge.

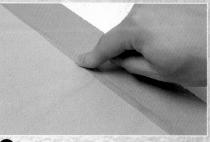

3 Stick a strip of tape along one edge of the paper, half on the paper, half on the board. Press down firmly.

4 Stick tape along the other three sides, and leave secured until the drawing is finished. When dry, cut through the tape.

Pastels

Dry pastels are sticks of pigment mixed with binder, usually clay and gum arabic. Hard pastels, or chalks, are

colored carrés, and pastel pencils are a wood-cased form of hard pastels that are good for detail in dry work as well as on their own. These pastels need to be fixed, but take care not to over-fix soft pastels or the resin in the fixative will dim their beauty.

pastels makes their colors particularly rich. Oil pastels vary from stiff to slippery; the softest mix well, and the stiffest are good for drawing details. Oil pastels do not dry, so avoid rubbing them, or use special oil-pastel fixative. Oil bars are oil paint in stick form and can be mixed with tube paints for oil sketching. They contain dryers and need no fixative, but

will smudge easily until dry. If you find drawing details difficult with oil bars' large, blunt tip, they are mixable with oil pastels.

Mixing pastels

The common feature of all pastels is that they are mixed when they are applied to the paper, not in advance. Because this is a slow process, manufacturers offer a wide range of shades to minimize the need for mixing, but because the available colors will not always match your requirements exactly, it is worth taking the time to learn how to blend colors. The main options are hatching strokes in different colors as separate drawn marks, so that the eyes see them blended at the appropriate distance; rubbing colors together while drawing; using a paper stump for soft pastels; or

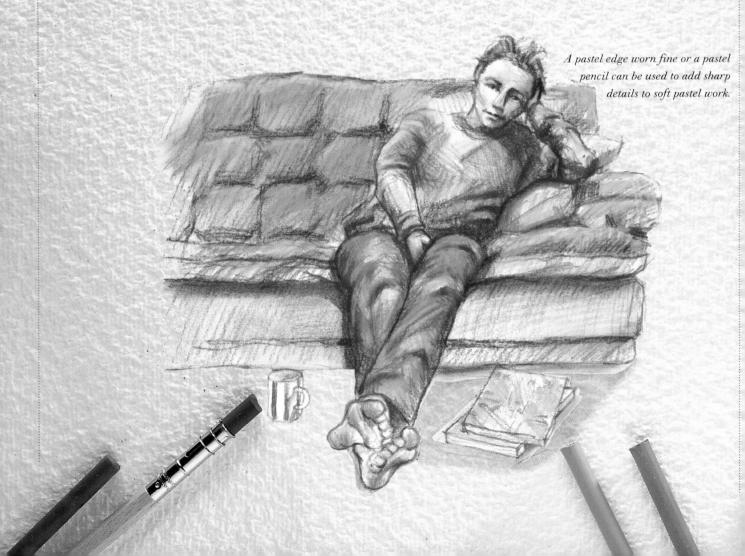

applying a wash of turpentine to oil pastels. In all cases, keep the process simple and the colors will stay clear; fussy work soon leaves dry pastels dry and lifeless, while over-washing with turpentine rapidly reduces oil bars and pastels to a thin, neutral deposit.

These problems are caused by the imperceptible amounts of many colors in complicated mixtures, which look muddy in combination. Expand your color list so that you can keep blends simple, adding light browns for darkening yellows, dark browns and purple for reds, extra-dark greens, and dark blues. Remember that black does not create effective shadows, as it colors mixtures. Unless they are particularly deep and somber, shadow values are richer versions of the color they fall on, so use dark colors to make them.

Fixing dry pastels

When finished, dry pastel work must be protected from accidental contact, either by framing in a mat behind glass, or by fixative. Practice spraying this on a scrap sample first, to calculate the minimum application required to hold the dust without dimming the color. Remember that the resin contained in fixative is a varnish constituent, and over-zealous spraying will set the opalescent pastel particles in a bonding coat of dull brown, extinguishing the brilliance of the colors permanently.

Blending with a cloth wiper is a broad treatment, removing dust from wide areas.

Blending with a bristle brush is controlled, as the brush edge provides definition.

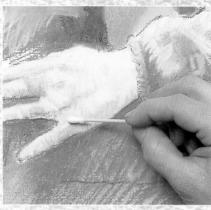

Small-scale, loosely defined areas can be blended with a cotton swab.

When kept clean, a stump allows specific blending with minimal removal of dust.

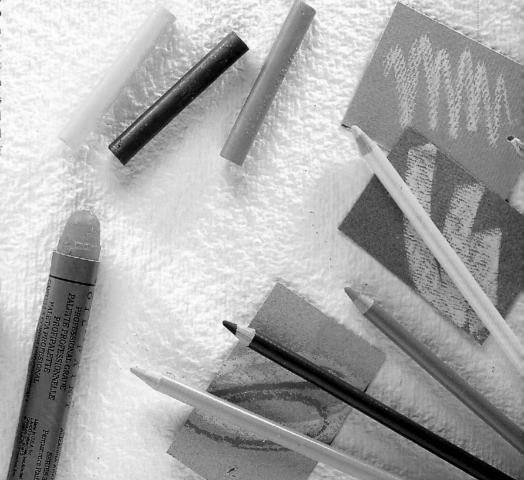

Colored and Aquarelle Pencils when it is densely covered. Firm drawing creates strong, bright colors, but start by

Colored pencils have a core of pigment with a slightly waxy texture that gives the paper a

surface

making faint marks; although a kneaded eraser will remove most of the pigment, the wax makes it difficult to erase colored pencils without any trace.

OLORED PENCILS ARE made in a wide variety of shades for surface mixing. True blending - where the colors mix and create a new shade - is not possible, so make color combinations by shading layer upon layer of light cover. Like wash drawing, different results can be achieved by using the same group of colors in another sequence, so experiment to find out the best order for a particular shade; note a stroke of each contributing color, and the order used, beside the final mixture on a shade card. Your color mixing will improve rapidly when you have examined all the possible combinations.

If you find it difficult to gauge how much pigment to apply to achieve the required strength of wash, try samples on scrap paper.

Create color mixtures and blends by washing over dry colors, or apply extra colors to dry washes and wash again.

Aquarelle pencils

Aquarelle pencils look like traditional colored pencils, but their cores are water-soluble. Hard and soft types are available, hard pencils being precise on wet paper and useful for adding fine details, and soft ones for making strong washes and reinforcing shades. They can be used as dry pencils, but the pigment dissolves when it is washed with clean water, making it possible to blend colors; if working this way, remember to stretch the paper first (see page 21), and be careful not to flood and wash out the work. To make alterations, erase or wash out the unwanted parts. Pale aquarelle colors are ideal for making preliminary sketches in wash drawings (see page 20) because they dissolve in subsequent washes, instead of staring through transparent colors like graphite.

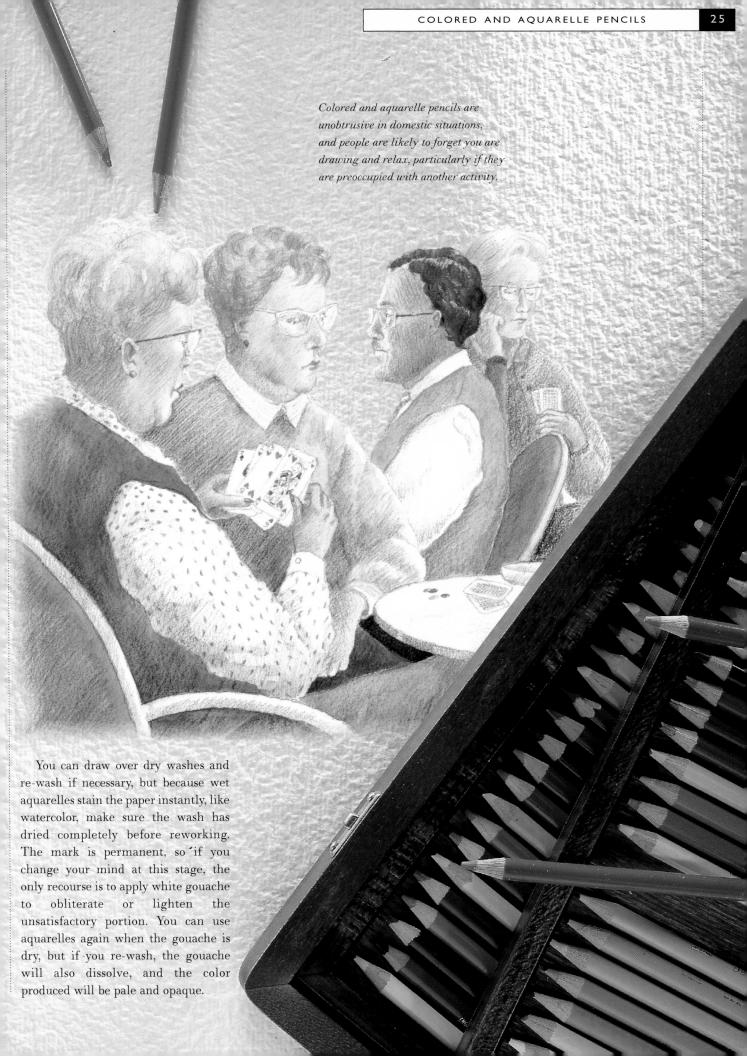

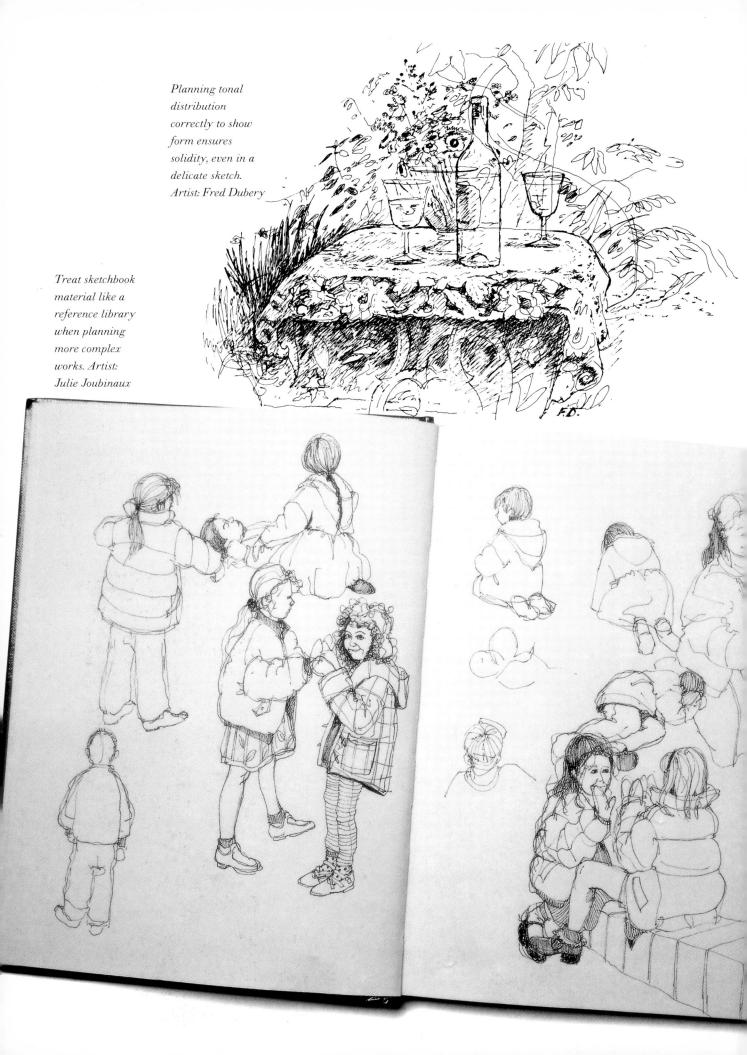

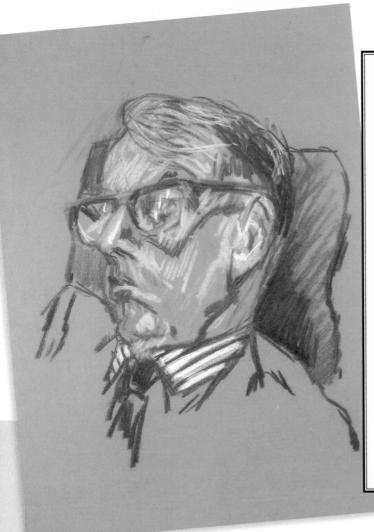

Planning and Drawing

Drawing is a practical task that benefits from a speculative pause before you begin. Choose the most suitable medium for the type and scale of subject, and for the time you have. Make sure that the materials and equipment you need are to hand. Examine the project you have in mind, and plan your approach with care, making thumbnail sketches to see what options are available. While drawing, budget your time so that you can complete the project within the span available.

Quick color sketches, in preparation for a portrait, explore the sitter's character. Artist: David Cuthbert

A rapid brush drawing helps to confirm that you are making the best choice of composition.

Artist: Ian Ribbons

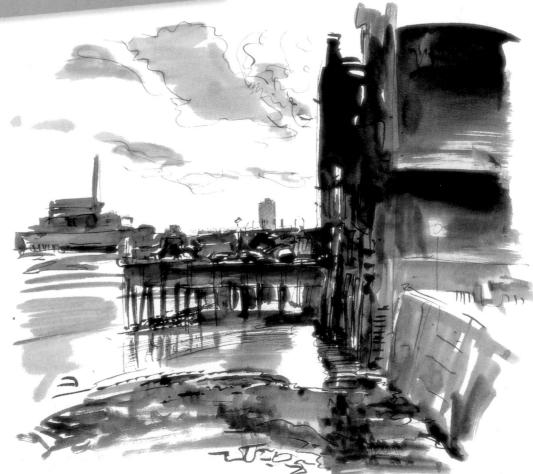

Viewpoint and Size

Drawing involves constant decisionmaking as you evaluate each mark you
make for its representative
qualities and adjust it as

necessary. Before you start work on a drawing, crucial choices must be made; deciding on the viewpoint and size determines how much of your subject to include in the picture, and the most appropriate size to enable you to realize the expressive and interpretative possibilities.

DITING IMAGES ON a computer allows you to remove areas and drop in alternatives, but the human eye simply scans and encompasses everything on view. Ignoring things that you see, or inventing things when your view of them is obscured, are difficult tasks and should be avoided. The perfect viewpoint is the one from which you are happy to draw all that you see within your chosen frame. To avoid drawing something, move it or find another position. Draw obstructions, not what you imagine is behind them, or move to a better viewpoint. The closer you are, the more details you see; the further away, the more comprehensive your vision. Use a viewfinder to help to determine the best frame for the image.

Make a durable viewfinder from heavy cardboard. Glue together three layers for each piece, with the central layer of each side piece narrower, to form a groove. Tape the top and sides together, and leave the bottom piece loose to slide up and down.

Choosing your distance

Distance will influence your choice of size. Unless you are close to your subject or are long-sighted, you will not be able to gather enough information to sustain a large drawing. Sight size — that is, the size that you see — is the easiest to draw. Work large from close up, and smaller from farther away. Drawing larger or smaller than you see can cause problems, because you must remember to enlarge or reduce each representative mark by the same amount.

A temporary viewfinder helps select a viewpoint on location. Holding your viewfinder close shows a wide vista; moving it farther away selects a smaller area.

Working large or small

Another factor that influences size is the time available. Large drawings are time-consuming, even in rapid media like washes or charcoal, and wide areas take time to cover; if your time is limited, a smaller scale may be the most practical.

In small works, even tiny marks will have great importance, and you may find yourself too cramped to explore extensive subjects. The advantages of working small are the option of using fine or delicate media, the ease of display in a domestic situation, and communication if the drawing is small enough to be faxed or scanned. Big drawings require large display spaces and more distant viewpoints, and are difficult to transport. That said, they offer increased impact and the chance to explore their textures up close.

Be flexible

The size of a drawing should suit the subject, the time available, the expressive possibilities, and the need to keep your approach flexible; if you always work on similar-sized drawings, you will find it difficult to change your approach. Because fragments and vignettes can lack credibility, work to the edge of the support wherever possible. Never trim drawings that appear to have surplus areas without first masking these off, to see how things look without them; reckless cutting can produce cramped results.

When arranging a still life group, consider the overall shape the objects make when assembled together. This will govern the initial impact of the composition, and influence the viewpoint you choose.

If time is limited, washes make a fast record of the shapes and colors, and serve as a color sketch for a more sustained drawing.

Format To determine the format way to turn the rectange and Focus

To determine the format of a drawing, decide which way to turn the rectangular support, and for focus,

choose how much of the picture you intend to

develop. Format can be determined with sketches or brief studies of all the possible options.

Focus is governed by the time available; short time spans or moving subjects make detailed work difficult to capture, while static subjects in an unchanging light can be treated in depth.

drawing surface is called the portrait format, although it is not always the automatic choice for a portrait or figure study. Similarly the lengthways, or landscape, format does not suit all open-air scenes. For example, a drawing of a reclining figure, or one seen in wide surroundings, may work best in a landscape format; and if high peaks or tall trees seem to be truncated in a landscape format, they may be better in a portrait one.

Consider your options; the most obvious format may not create the best design. Your choice should take account of the shapes of the negative spaces as well as the positive forms of the objects in your composition.

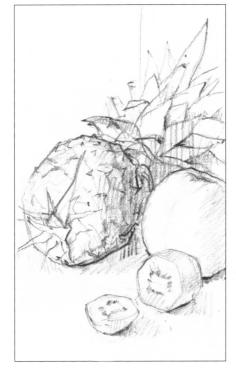

Format

Make the format suit your design because amateur photographers take snapshots rather than composing their pictures, photographs often include arbitrarily cut images, but you should leave nothing to chance when investing time and effort in a drawing. Examine the possibilities carefully, and choose the format that produces the most exciting design. If your sketches indicate that a wider or narrower rectangle, or even a square, gives a better design, change the dimension of the drawing surface; remember, though, that if you want to exhibit or display your work when it is finished, unusual formats need custom-made frames, and these can be expensive.

Focus

Focus is concerned with the process of selection by which you determine how much or how little to represent in detail, allied to the depth of the whole drawing. In addition to showcasing the parts of the drawing that you want to command attention, you will need to suppress less important ones, partly by developing the elements of maximum impact in full detail. This draws attention to the details as the eye is drawn naturally to highly worked areas; the simpler parts are needed as a contrast to the busy elements, and will be viewed with less intensity.

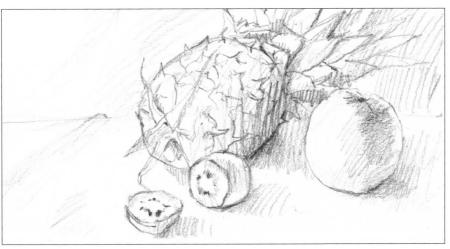

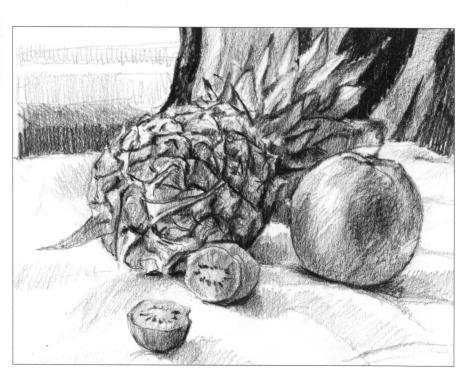

Exploring in monotone helps to determine which areas to work up in detail in color.

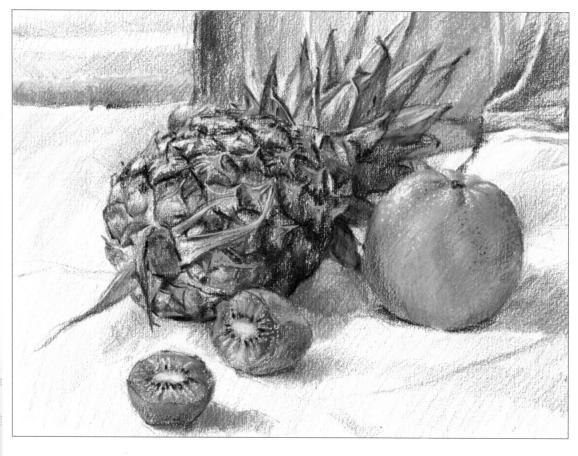

Decisions about focus are personal, so develop the qualities that hold most fascination for you, subject only to the safe prodedure of working broadly at first and refining details later.

Decide which areas to work up and what to treat broadly by consulting your sketches and choosing where you want to center interest. Look at the directions of the lines in the layout and, because distance obscures detail.

consider the three-dimensional depth of the picture. You can also focus attention by slightly increasing the tonal contrast in the chosen area: brightening the light values and enriching dark tones draws the eye to

them almost imperceptibly. Make sure that such adjustments are subtle, and avoid over-emphasizing contrasts, because this will upset the tonal scheme and cause changes in the perception of space within the drawing.

Design in Two and Three span Dimensions

Drawing creates

the illusion of

three-dimensional

space on a two-

dimensional

surface. When

drawing from observation, you are opening an imaginary window for a viewer to look through at your representation of reality. The visual journey, around and through this spatial illusion, needs to be organized. By making sketches or thumbnail drawings beforehand, you can check the two-dimensional layout or the distribution of shapes across the flat surface.

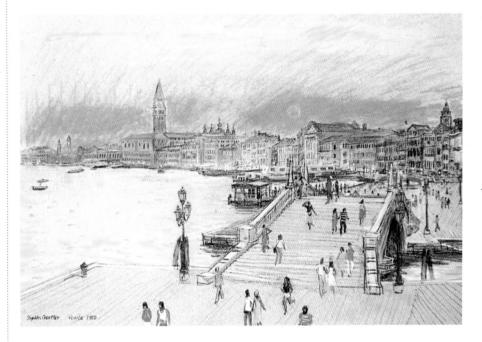

EVENING IN VENICE

STEPHEN CROWTHER

Much of the atmosphere in this drawing is created by the use of color throughout: note in particular how the colors of the clouds and sky are repeated in the water and on the buildings and lamps. The delicate shades on the smooth sweep of the water are in contrast to the brighter colors on the figures in the busy foreground. When establishing a view, there is no substitute for direct observation. (Charcoal and pastel)

WO-DIMENSIONAL DESIGN is concerned with the flat layout of a drawing and the dimension of forms and spaces, lights and darks, plain areas and textures, across the whole span. Draw into all the areas as you define them, rather than treating them as linear silhouettes. Work broadly at first, then in more detail as you verify your original statement – this approach helps you to draw accurately. Line drawing is fast, but because it involves

drawing white spaces that are hard to evaluate, it makes it difficult to establish proportions and dimensions.

To convey solidity, you need to trigger the perception of threedimensional space. There are many techniques for achieving this; the most useful give visual clues that the viewer associates with an experience of real space, and are usually simple. The first technique is vertical perspective, which creates apparent recession by arranging items vertically in the picture while diminishing their scale. This relies on the understanding that distance makes elements and the spaces between them appear smaller. This particular illusion is more convincing if you overlap items, because intervening objects often obscure distance in reality.

Single-point perspective is a mathematical system that represents visual space by identifying a vanishing point, the spot on a nominal horizon where

the extensions of all the horizontals in a drawing would vanish. Draw everything horizontal to the picture plane so that it appears to slope up if it is below your eye level, and down if it is above. This creates diagonal directions that are useful for bridging the lattice of horizontal and upright lines on view. Semicircular alignments also have a role; by selecting them for emphasis, you can use them to move the eye from one stopping point to another, across and through the span of a drawing. Vertical forms provide punctuation points among the horizontals, and also appear to diminish with distance. Draw them progressively shorter, and reduce the spaces between them. Remember that anything vertical to the picture plane must be drawn upright; a slope creates an illusion of falling.

Busier subjects require more subtle organization; as you gain confidence, develop your skill in conducting visual journeys within drawings. Tackle more complicated themes by increasing the number of different items at different angles to the picture plane; this calls for multiple vanishing points, ands offers complex design opportunities.

Vertical forms punctuate the horizontals.

Clouds reinforce the vertical perspective

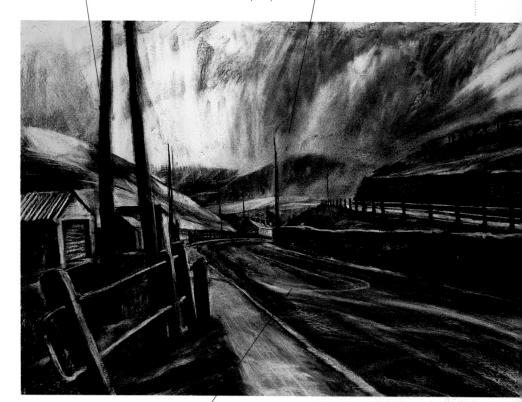

semicircular marks move the eye across

THE GRAIG DAVID CARPANINI

Here, what might at first seem to be a rather bleak view is transformed into a powerful, vivid drawing by the use of the different perspectives. The angle of the rail in the left foreground becomes the sweep of the road in the distance, dramatically broken up by the telegraph poles, while the rails, hills, and clouds on the right pull the viewer toward the row of houses. (Charcoal)

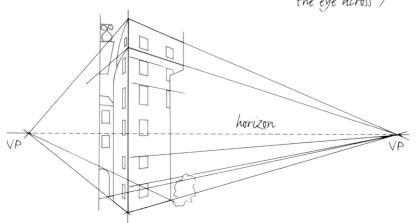

When drawing a form such as a building using two vanishing points, make sure that all the angles conform to both points.

With multiple vanishing
points, using a high horizon
line creates an enclosed
feeling in the foreground.

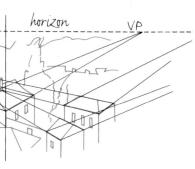

Still Life: Graphite

THE BEST MEDIUM for a first look at design is graphite. By using this flexible drawing substance, that can be erased without trace if necessary, you have a responsive medium for examining the two-dimensional layout and the three-dimensional structure of your drawing. A 2B graphite stick provides quick covering power, and for subtle effects, apply graphite powder with a stump or brush. If you block in the tones softly, you will have a preview of the composition before you draw a line. A drawing-grade pencil, such as a 2B, gives the precision required for definition and detail work later.

Materials

Hot- or cold-pressed (not) watercolor paper, or acid-free drawing paper • 2B drawing pencil • 2B graphite stick • Stump or wiper • Plastic eraser • Craft knife • Fixative

Thumbnail Sketch

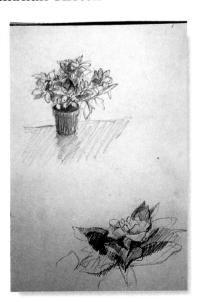

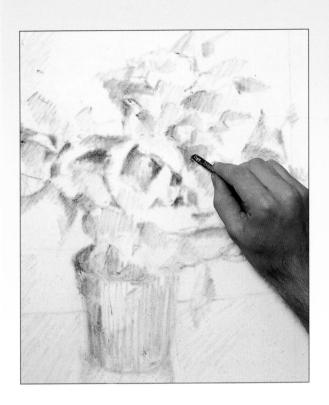

Draw in tone alone

Linear drawing makes evaluation difficult, because the flat, white shapes you enclose will not correspond to the three-dimensional lights and darks you see. Until you become more practiced at drawing line and tone together, draw the tone first using graphite powder applied with a stump. This also makes it easier to erase.

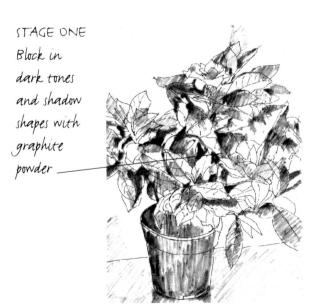

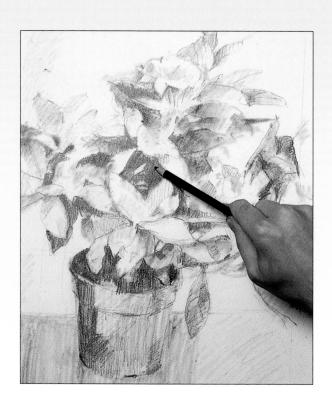

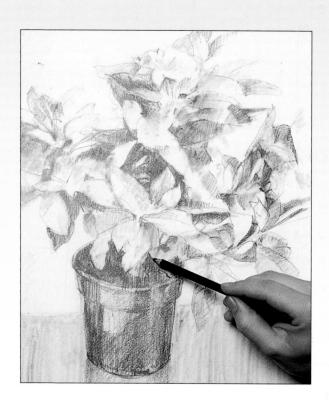

Define the structure

When you are satisfied that the tonal work is describing the plant's three-dimensional character, use a pencil to define the main divisions between the pot, leaves, and the important negative shapes between them. You need to pin down the divisions, to build a sound framework for structuring the drawing later.

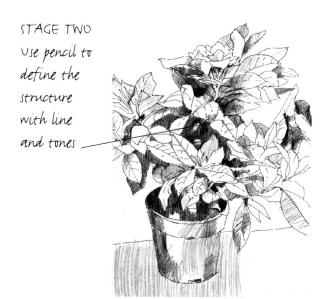

Create protuberance and recession

Evaluate whether both the two- and three-dimensional designs are working as you intend, then reinforce the deepest darks and clean up any light values that may have been shaded over. Ensure that all the recessive elements are pushed back, and that the protuberant parts of the drawing appear to come forward.

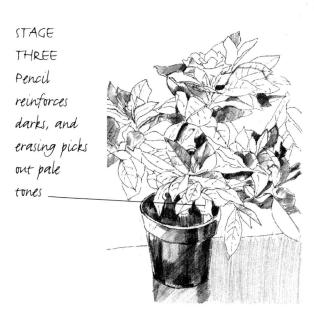

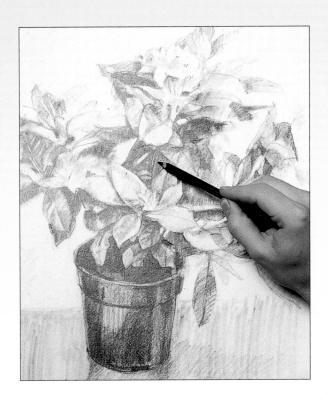

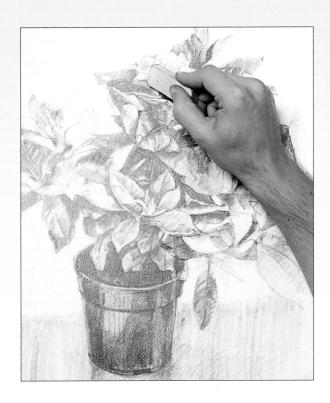

Refine the definition

The drawing can progress rapidly now, because you have completed all the major tasks. Fix the particular shapes of leaves, or the group shapes they make if you have decided against drawing every one. Pay particular attention to the perspective of the plant pot, because it can still be amended if the ellipses look too shallow or deep.

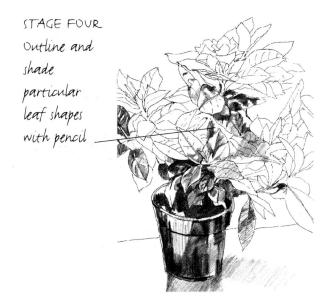

Check the overall effect

Check the tonal scheme of the plant's surroundings. Although the background should be worked up equally at all stages, work on the tonal areas of the plant can leave it looking pale. Stand back regularly to evaluate, because elements may become too dominant or effaced for want of a proper check. Now work into the subtlest tonal nuances.

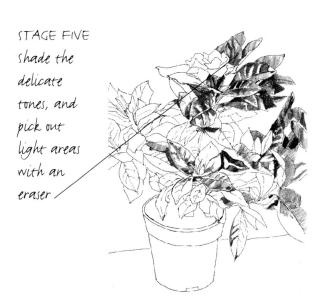

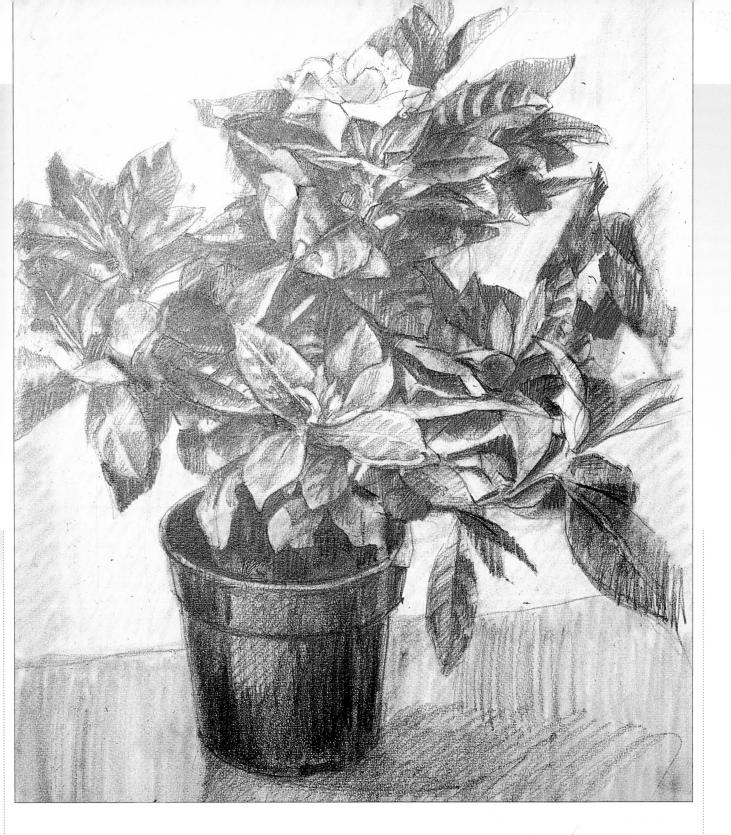

CAMELLIA

IAN FELLOWS

Graphite is easily smudged, so in the final stages of your drawing, check thoroughly to make sure that you clean up any blurred forms by removing the unwanted smear with an eraser. To finish, refresh richer lines and tones that have been softened by smudging, and fix lightly.

Townscape: Charcoal

THE ADAPTABILITY OF charcoal makes it a medium that is ideal for studying perspective; marks can easily be removed or altered, even on large, expressive drawings. Drawing in urban areas, where buildings offer a variety of receding lines, is an excellent way to come to terms with perspective. Rather than an exacting art that requires study, perspective calls only for close observation and practice. Using charcoal with white chalk or white compressed charcoal on a mid-toned paper can add another angle to the achievable range of tones. Mid-tones can be achieved by simply leaving the surface of the paper to show through.

Materials

Tinted cartridge paper • Medium willow charcoal • White compressed charcoal • Kneaded eraser • Fixative

Thumbnail Sketch

Find an interesting viewpoint

Start with loose, easy strokes to outline the general structure of the composition. By taking a viewpoint slightly off-center, you will give your drawing greater interest and tension. Rub marks out with your fingers or an eraser until you are satisfied with them; with close observation, you are building the main lines of perspective that establish much of the drawing. The erasable qualities of charcoal help this to be a stage where you can experiment freely.

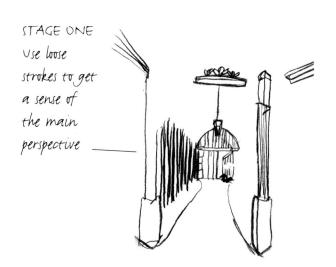

Create a sense of depth

Lines of perspective will draw the viewer's eye around the page; by developing the areas to which interest is drawn, you can create a sense of depth. In a drawing of buildings there is usually a complicated structure of receding lines—it is more important to get a believable and consistent portrayal of this than a mathematically exact one. The thickness and quality of line will help areas to recede or come forward.

STAGE TWO
Vary the
quality of
line to give
added depth
to the image

Keep marks fresh and lively

The areas around the main focus of interest are important to the overall composition: lines that leave the edge of the paper, for instance, can draw you into the central scene. The perspective in these areas can become quite exaggerated, because you will be drawing walls or roofs that pass over and around you. Keep your marks fresh and confident — there's nothing you can do to the drawing that can't be amended at this stage.

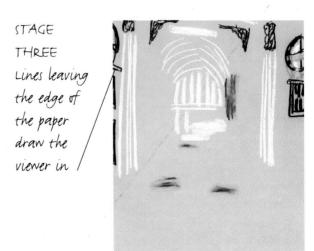

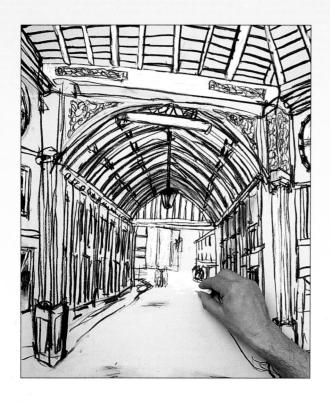

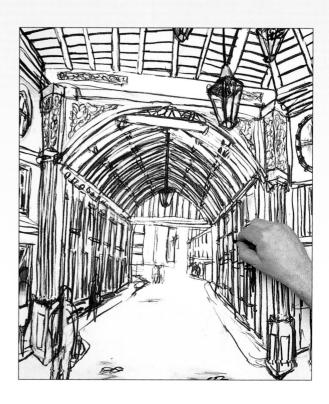

Introduce highlights

By using black charcoal on tinted paper, a range of opportunities is opened for introducing white highlights. Mid-tones can be achieved by leaving the surface of the paper untouched, and a range of grays can be created by rubbing charcoal with your fingers. These changes in tone can be used to your advantage in developing the sense of perspective; light highlights in the distance accentuate the dark passages that lead to them.

STAGE
FOUR
Light
chalk can
highlight
the brightest
areas of the
composition

Position finer details

With the basic structure of the composition now in place, introduce the finer details. These should be consistent with the perspective you have created. Figures, especially in busy places, can give the impression of movement and bring life to static buildings. As the picture continues, you may find it necessary to return to some areas, to give them greater emphasis or to clarify lines of perspective — look closely to see to what degree the lines of a building vary from the horizontal.

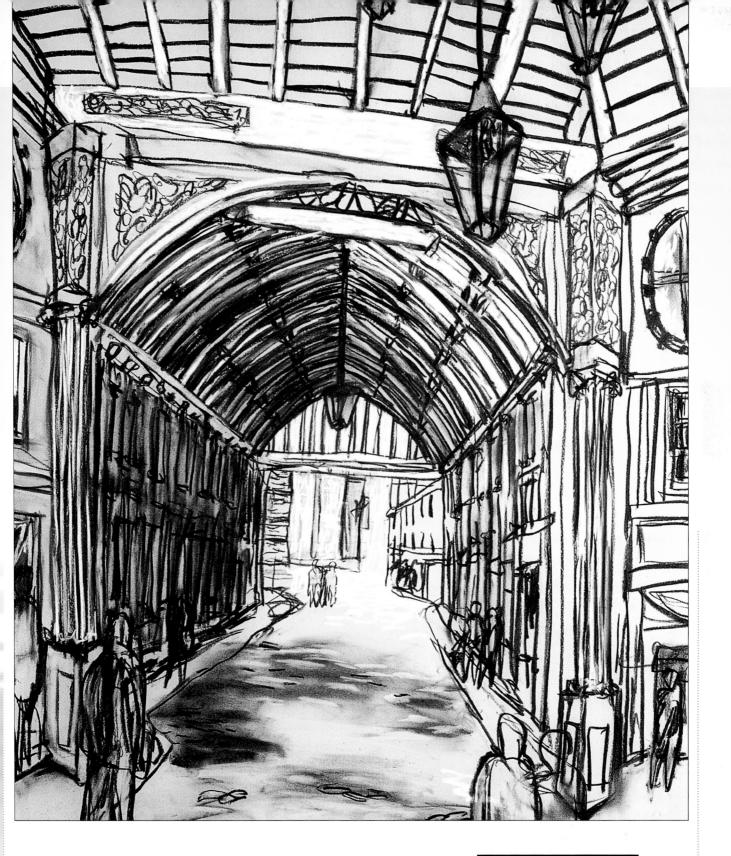

COVERED MARKET

JAMES HOBBS

Continue to make corrections and adjustments throughout the drawing. Use the sharpened edge or point of an eraser in charcoal-filled areas to bring back the paper's surface and introduce highlights to shadowed parts of the picture.

Gallery

LARGE, SIMPLE FORMS are easy introductions to the organization of two- and three-dimensional design. As you gain in confidence, move from compositions that are rectangular, or composed of straight elements, to more complex, curvilinear designs. Remember that asymmetry has more visual interest than a rigidly balanced design, so include some diagonals within a rectilinear format, or straight elements in a mainly curving composition.

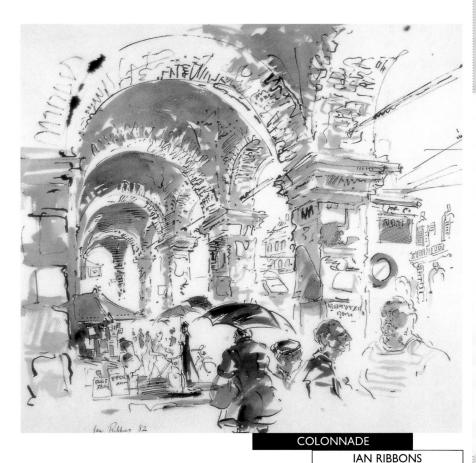

Attention points

Architectural settings are a useful basis for drawings where correct perspective creates a convincing three-dimensional design. Diminishing size is one of the visual clues to recession, and the decreasing scale of the arches, columns, and figures in this pen and wash drawing helps to persuade the viewer that they are looking at a vista with real depth.

- Organize the flat, two-dimensional design so that the intervals between the elements diminish in the same ratio as the columns and other positive features.
- 2 The illusion of lofty ceilings and looming features gives the setting an air of grandeur. This effect can be managed easily if the floor is depicted as close as possible to eye level, while the roof and the recession down toward the vanishing point are shown as a steep incline, implying a ceiling of considerable height.
- Whether they are arches, columns, or figures, overlapping elements are characteristic of distance, and add to the illusion of space; use them wherever you can to create the impression of depth.

4 The alternating bands of shadowed recesses and dimly lit arches create a repeating pattern that adds a decorative element to the two-dimensional design. Remember to consider the impact of this when placing the colonnade within the rectangular format.

Key Planning Points

- Keep tones and colors somber, to imply the low light levels experienced under colonnaded arches, but soften them slightly in the far distance
- Identify bland areas to serve as a contrast to the textured surfaces of brick and stone

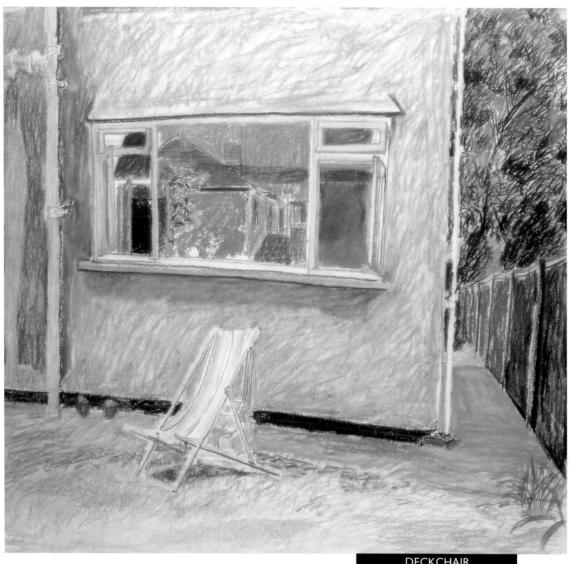

DECKCHAIR

ROZ CUTHBERT

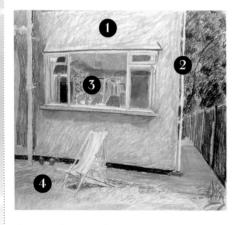

Attention points

This oil pastel drawing uses the path at the side to imply depth, together with the receding fenceposts. Details such as the drainpipes serve to anchor the main rectangular form at the correct depth.

- 1 The elevation of the building is not square-on to the picture plane. The slightly slanting quality is a key design feature in adding interest, while staying close to a full-frontal presentation.
- 2 Although identical in direction, the parallel verticals of the drainpipes have different dimensions, adding reinforcement without repetition.
- The rectangle within a rectangle of the window frame is a foil for the slack curve of the deckchair. With its real and reflected space, it adds an element of ambiguity in a view where other elements are solid and tangible.

4 Color influences the perception of space; here, two opposite colors, yellow and purple, dominate the design. The result is not discordant, due to the bleaching effect of sunlight, and the presence of neutral greens and browns.

Key Planning Points

- · Because such a design depends on the proportions of the various rectangular elements in relation to each other, plan the areas to be occupied by the flat planes with care
- Keep all the elements in perspective

Form and Space of the surface of the

Forms, the positive shapes in space, are revealed by the fall of light across their

surfaces. Between forms lie the negative shapes of the spaces. Forms and negative shapes are

equally important in a drawing; focusing on forms alone deprives you of an evaluation tool, and it is only by checking the dimensions of the negative spaces against the positive forms that you can be sure they are both the required size and shape.

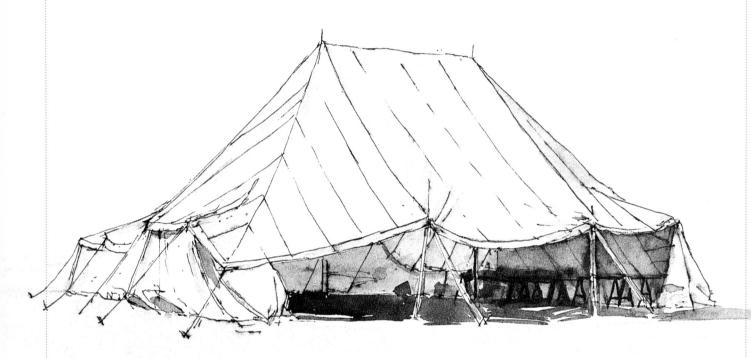

display contour changes. Look for evidence of these by identifying surface details that show the underlying form, as they twist or turn around the contours, such as roads or fences in a landscape, or stripes or check patterns on a garment. Cast shadows with clear edges also disclose the contours they fall across, but take care how you treat such shadows: if the shadow edge is blurred, this indicates a softer view of form, so don't misrepresent this by sharpening the shadows.

The nature of forms is easier to identify when several are contrasted with each other. Look for varied qualities, such as rounded and angular, taut and slack, or broad and narrow, that are close to each other. You can find these qualities juxtaposed clearly when figure drawing in a domestic situation, or outdoors in an urban or rural setting.

When drawing complicated forms, such as trees in leaf, pay close attention to the different qualities that are revealed by light. Once you have

TENT

MICHAEL WOODS

A partly collapsed tent being re-erected provides a contrast between taut and crumpled qualities of form. The tonal contrast, between the strongly lit exterior and the low light levels glimpsed inside, enhances the three-dimensional effect, and endorses the illusion of an inner space under the tent ridge. Gently curved sections show the fabric contour across the surfaces of the massive form. (Pen and wash)

CONCH SHELL

PAUL MILLICHIP

The convex, asymmetrical form, concave, enclosed space, and real and reflected surrounding spaces of a shell do not require minute detail to be convincingly portrayed. Economy of means is a hallmark of good drawing. (Charcoal)

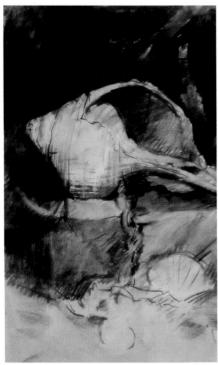

however loose your interpretation of your subject, aim to develop the habit of assessing form and space together and against each other. Contemplating both the negative and positive elements gives a complete overview. It enables you to adjust a drawing where necessary, and offers faster results, because you can build on certainties at an early stage in the work.

When drawing solid forms, employ the negative shapes of the surrounding spaces positively. If these tally with the shells, then the forms are verified; if not, assess and adjust as necessary. Define the boundaries of the image, otherwise an arbitrary overall shape will register and cause confusion as the viewer attempts to interpret it. (Pencil)

You can assess the qualities of space equally well by observation. Draw negative shapes as carefully as positive forms, both to affirm the dimension you give to adjacent items, and to keep control of the three-dimensional design. If you make an inaccurate drawing of positive forms, examine the dimensions of the negative spaces; this will highlight any discrepancies, because the two elements must tally.

The degree of accuracy for which you strive is a personal matter, but

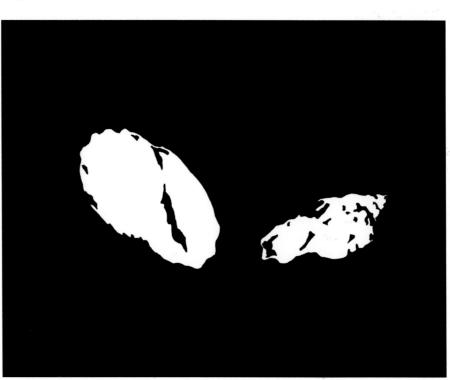

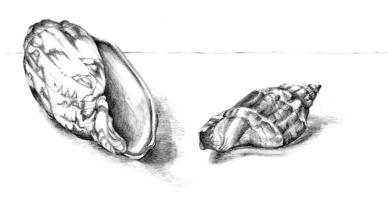

Townscape: Carré

A SIMPLE SUBJECT helps you to gain experience in the molding of visual elements that are seen as positive shapes or forms, together with the open or empty places of space. An uncluttered interior or large outdoor views offer the best opportunity of depicting the fall of light across surfaces to reveal form, without fussy detail. Whatever you choose, aim to make a powerful, succinct representation of positive form and negative space. For a townscape, make thumbnail sketches until you are sure that your buildings are in perspective, and experiment with colored media to soften the starkness of a simple view. Working in an attractive medium, such as sanguine carré, can enhance an urban scene.

Materials

Acid-free drawing paper • Sanguine and white carré crayons • Stump or wiper • Kneaded eraser • Fixative

Thumbnail Sketch

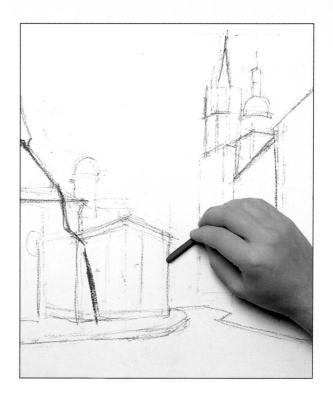

Organize the perspective

Make sure that your viewpoint includes natural forms, such as trees, to relieve the solid masses of the architecture. Drawing these elements together makes it easier to estimate both types, because the regular forms of buildings reveal the degree of curvature, the asymmetrical angles, and idiosyncratic shapes of trees and plants by contrast. Errors in perspective will be noticeable, so sketch your scene briefly in line alone until you are satisfied with it.

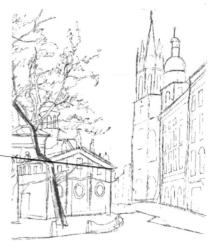

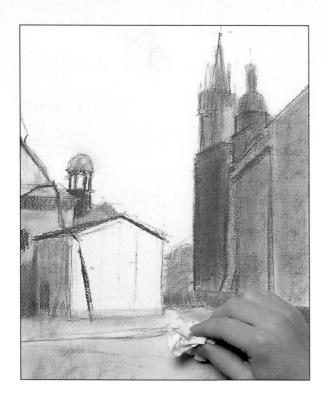

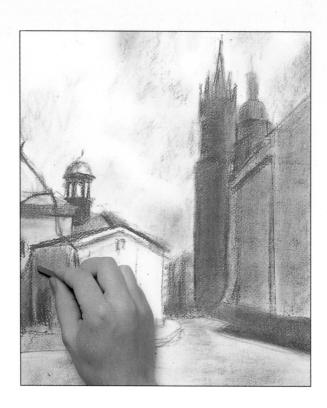

Determine the main tones

Decide whether you want to preserve the crisp freshness of the carré by using drawn marks alone, or soften and blend it. If blending, do this as you draw rather than at the end, when the tonal scheme will be hard to organize all at once. Softening can be done broadly with paper, cloth, or a dry brush, or precisely with a paper stump. Draw in the preliminary tone on the major items, so that you can see the values against each other.

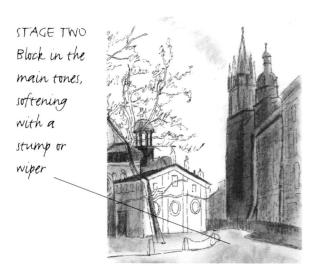

Complete the tonal scheme

Although you want to focus attention on key features, every aspect will eventually come to be noticed, so let nothing slip: often-neglected areas include skies and road surfaces, both of which can occupy a large part of a picture.

Incorporate such areas in your tonal scheme right from the start, so that you are always evaluating a drawing as closely as possible to what you actually see. This makes spotting and correcting any discrepancies much easier.

STAGE
THREE
Draw in and
soften the
secondary
tones across
the whole
scene

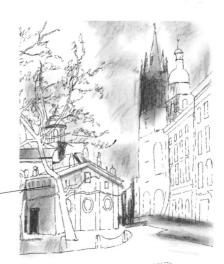

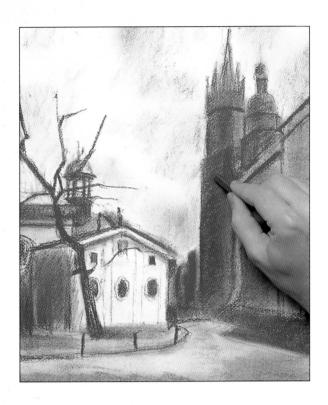

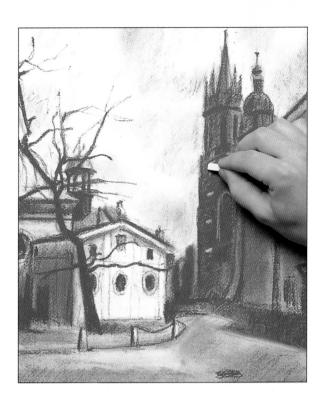

Develop the secondary features

Check perspective by standing back and comparing your drawing to the view. When satisfied, reinforce the tonal strength while drawing the larger details and architectural features. Now you can be certain that you are investing your time well, because you have put in the proper groundwork. Adhere to the rules of atmospheric perspective, and remember that even the richest darks will lose tonal strength if seen at some distance.

STAGE
FOUR
Reinforce
the richest
darks
strongly,
and draw
the large
details

Adjust the minor tones

Examine the light areas, and check that the slightly darker tones visible within them are not as deep as the values of the shadows. Make sure that no lighter shades apparent inside shadows are as bright as the lit areas. Other smaller tonal changes can be inserted now. If you are depicting a pale-colored feature against a darker background color, this can be drawn in with a white carré. Now complete the smallest details of the drawing.

STAGE FIVE
Draw pale
features
with white
carré, and
adjust light
tones

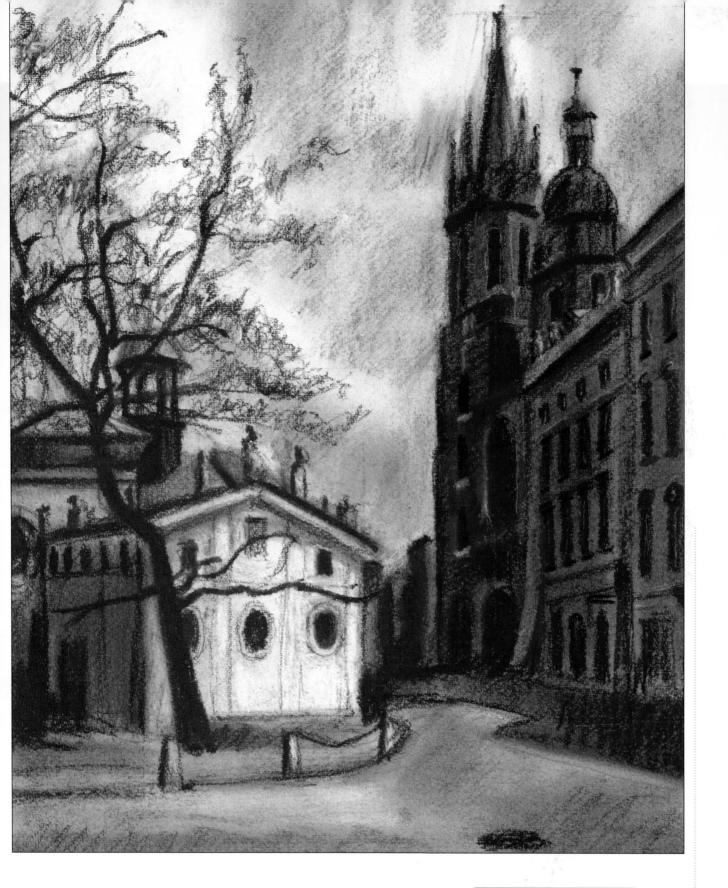

KRAKÓW

IAN FELLOWS

Check for discordant values by half-closing your eyes and peering through your lashes. Use a kneaded eraser to lift the dust from any over-strong tones, then fix the drawing.

Portrait: Wash

RESIST THE TEMPTATION to put off figure drawing until you feel completely confident; plenty of time will pass while you wait, and you may miss all the fun! Accept that while your early studies may not achieve a likeness, they improve your drawing more rapidly than any other subject; figures contain many contrasting forms — bony and soft, taut and slack, curved and straight. A medium capable of conveying subtleties is a good choice for such variety. Ink washes are infinitely variable and will do the job perfectly, provided you dilute your initial wash and remember that you can't erase them.

Materials

Rough or cold-pressed (not) watercolor paper • Dark, warm-colored watercolors or inks • Mop brush • Detail brush • Mixing palette • Small sponge • Gummed paper tape

Thumbnail Sketch

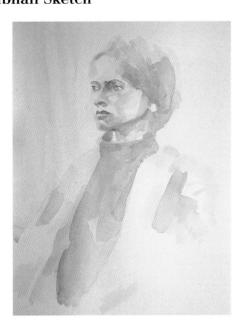

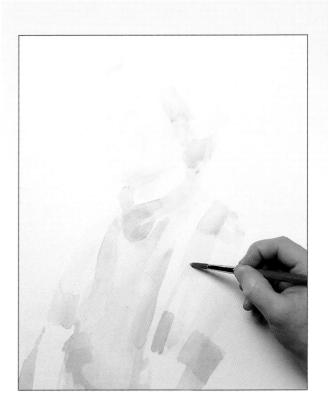

Draw forms in pale tones

Until the proportions are resolved, use ink thinned to a pale wash. Waterproof ink has a varnish content, making it impermeable when dry, and it will curdle unless mixed with distilled water. Test the dilution strength on scrap paper before laying down washes to represent the main forms in pale tones. If they are misplaced, flood them with water, then blot them off with a moist brush, sponge, or dry, absorbent paper immediately.

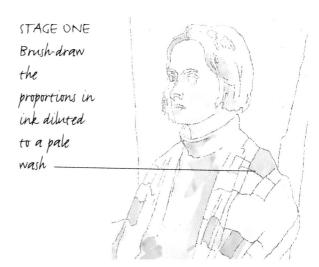

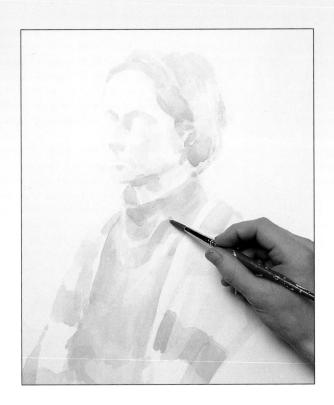

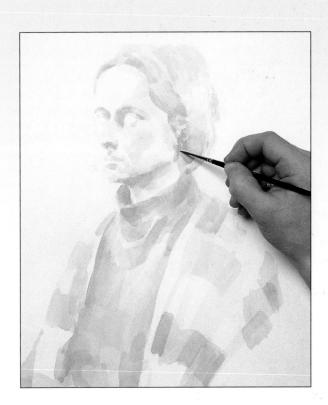

Check the negative shapes

Complete the overall pose in paler values, being careful to damp the paper in areas where you want to spread an even wash. Watch the positive shapes your sitter makes against the background shape of the space around, and take care that the negative shapes confirm your statement of the positive form. If not, alterations are still possible, because you are working in pale values. Just darken your wash to a stronger mix and override the first sketch.

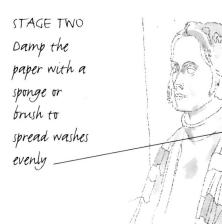

Strengthen the forms

When you have established the figure in muted form, check that the overall dimensions are accurate, and then begin strengthening the cast shadows that show form, by laying a second pale wash over the appropriate passages. Do this as crisply as possible, always looking at your sitter for observations to inform your descriptive work. Washes that are reworked several times will look tired; by checking and adjusting each time, they will retain freshness.

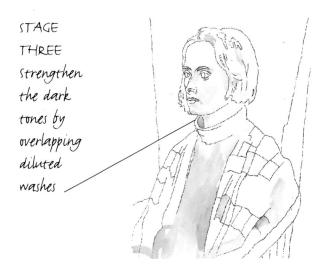

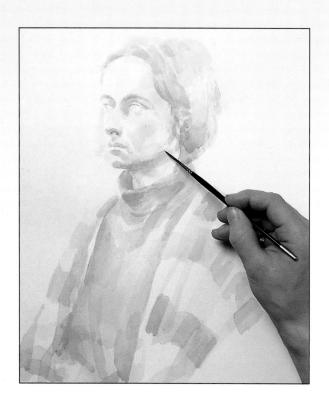

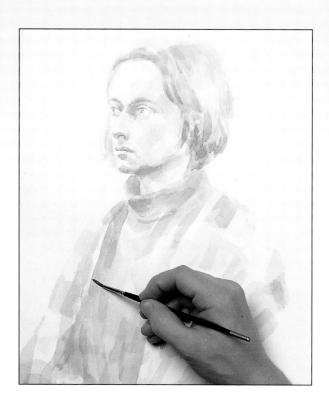

Preserve brilliance

Overlays of light washes accumulate strength surprisingly quickly, as each wash excludes more of the white paper. As you finish bringing the tonal scheme up to full strength, make sure that you preserve the lighter tones, that rely on the paper surface for their brilliance. Areas where corrections have left darker tones than you want in some passages can be redeemed later with opaque white gouache, or careful scraping out.

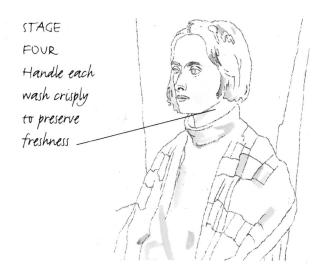

Develop forms evenly

Your main interest will be the likeness you want to achieve, but to create a plausible rendition of form in space, your developmental work should include more than the portrait head. Encompass the rest of the figure, up to the point where you have decided to cut the image: head and shoulders, half-length or full-length. Work on the form of body, limbs, and their clothing as well, until you have a plausible image of three-dimensional form.

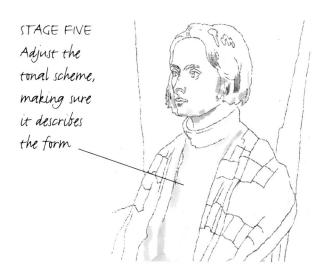

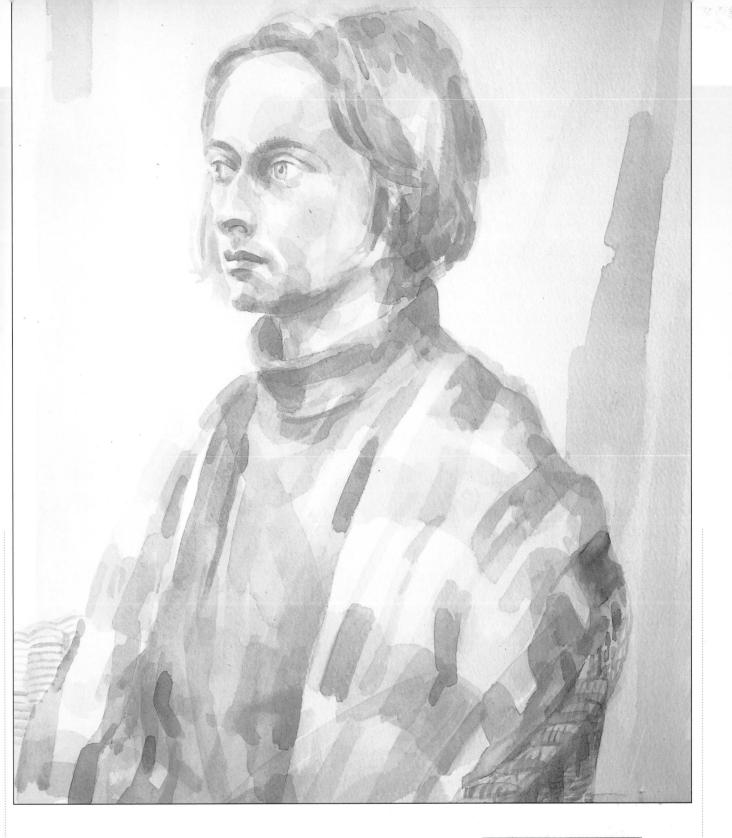

MOIRA

NICK HERSEY

Now that you have established the richest tones, pay attention to the nuances that show the subtler changes of form and contour. Always include the background in the process, as the tonal qualities of the surrounding space are vital for comparison in discerning the values of the figure.

Gallery

IF YOU WORK intuitively, without conscious understanding of the underlying concepts, knowing what factors require your attention will help you to improve. Address the right aspects in the correct sequence — more understanding of form and space will result in a better representation of solidity.

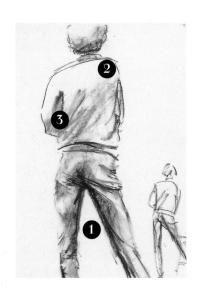

Attention points

This charcoal and conté drawing depicts a human figure standing at an angle. This is an excellent subject for studying the contrasting qualities of form, because many of these qualities, such as taut and slack, broad and narrow, sharp and blunt, can be seen in close juxtaposition.

Standing with the weight on one leg changes the form of a figure, tilting the hips as the body balances itself automatically in order not to fall. Observe the stance best by noticing the area of triangular space enclosed by the legs.

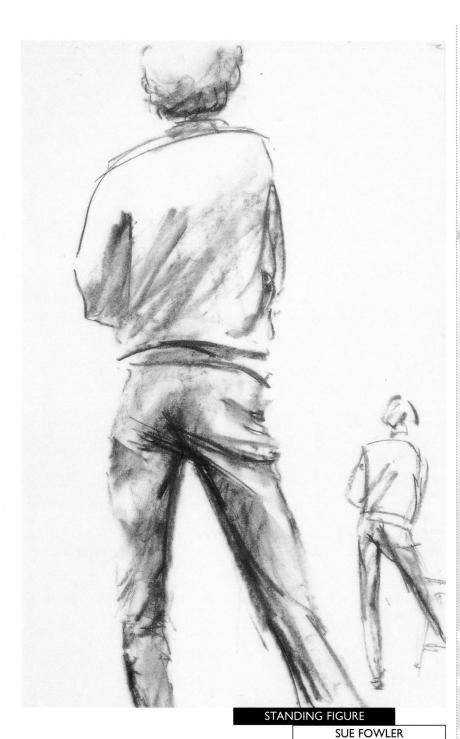

2 As the body moves to retain balance, expect to see the shoulders slanted in the opposite direction to the hips.

3 Observe the shadowed areas that show form turned away from the light, and block in the main areas. Include only major folds in garments at first — smaller details can be added later once you are sure you have created the correct effect.

Key Planning Points

- Note the direction of the light, and depict it consistently
- Take spaces into account when composing a picture
- Represent large forms first, and details later

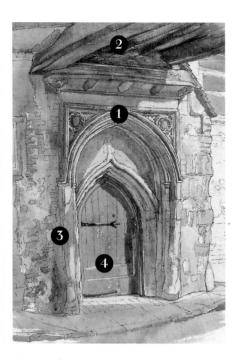

Attention points

It is light that reveals form, and directional lighting creates shadows that help you to realize convincing three-dimensional images. A raking light, such as the sunlight shown on this medieval doorway, illuminates the protuberant surfaces, while the recesses and undersides are characterized by heavy shadow. Because shadows describe the contour of the surface on which they fall, draw them with care. Here, sepia ink and watercolor washes simulate the lighting effects beautifully.

1 The strong, geometric shape of the arch within a rectangular surround is a dramatic form, close to the appearance of a theatrical stage. It calls attention to the center, but the surrounding spaces need careful consideration if it is to be placed comfortably within the similar rectangle of the portrait format.

2 Pay attention to the sloping diagonals of the overhead beam and roof shingles, and the echoing slope of the path below. These are important visual elements that confirm the three-dimensional illusion through the use of perspective, and provide a contrast to the rectangle within a rectangular device.

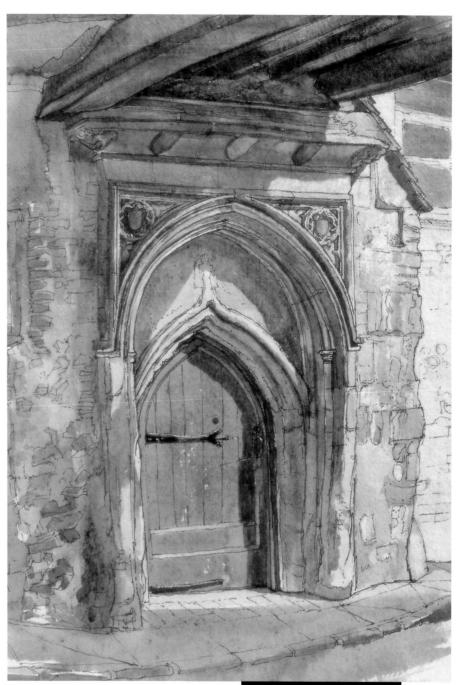

DRAGON HALL DOOR

MICHAEL WOODS

3 Draw the qualities that characterize form. The rugged beams and pillars show off the delicacy of the stonework over the arch, while the uneven wall surfaces counter the smoothness of carved stone.

4 Reinforce tonal strength to achieve the correct effect of recession, and add details, such as joint and planking, that help to reinforce the sense of perspective.

Key Planning Points

- Choose a paper surface that will show washes well
- Include enough brilliance to counter the somber tones
- Sunlit effects are transient; return to finish the drawing if necessary

Tone

Shadows are cast on surfaces that face away from a light source.

You need to develop methods for shading or highlighting areas

according to the degree of dark or light observed – in other words, the tonal values – otherwise your drawings will appear flat. Subtle tonal changes are difficult to discern when looking full at a subject. Half-close your eyes and peer through your eyelashes; this screens out small variations and shows only the deepest dark and brightest light areas.

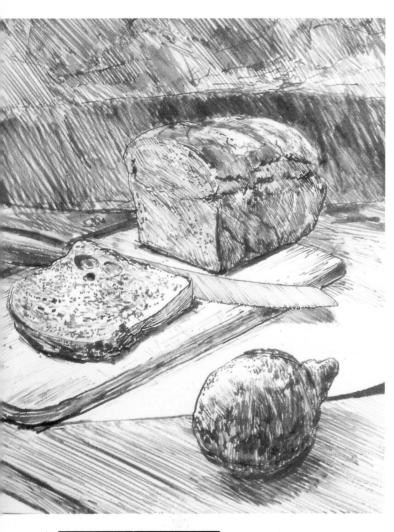

A LOAF OF BREAD

VALERIE WIFFEN

Hatching, or linear shading, will build up tonal density in pointed media. Easily graded for tonal strength, it describes curved, as well as flat, forms by depth of tone and location. (Pencil)

Consider the aesthetic qualities of your marks, too: unless you are drawing something you specifically want to express with an ugly mark, avoid techniques that produce unpleasant visual effects. Any non-specific mark that is hidden from view when it is made, such as rubbing with a finger, will be difficult to grade, arbitrary, and uncontrolled — and is best avoided. Once you have identified a specific mark that you can create comfortably and reliably, you are ready to draw.

First, study the subject, noting the depth and intensity of the shadows compared to the brilliance of the well-lit elements. Determine the extremes of tone, then begin to note down their

It's a good idea to experiment with the full tonal range of various media. Draw a test strip and see how many different tones you can achieve.

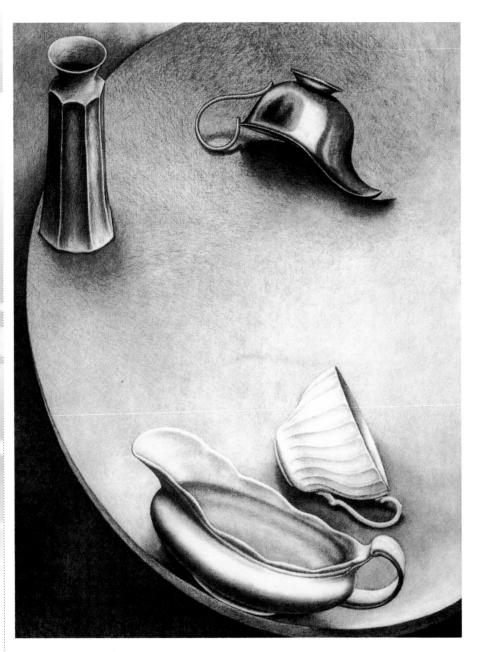

The filtering effects of dust particles in the atmosphere make distant tonal values appear pale. This is atmospheric perspective, and you can organize spatial recession in a drawing with the aid of variations in tone as well as the design structure. Remember that the strongest dark values are perceived as close, and softer values seem farther away; at a distance, even the richest dark values are dimmed.

GRAVYBOATS

SARAH ADAMS

Distinctive tonal changes on glazed or metallic surfaces can be represented subtly, by effacing your habitual marks and creating tonal strengths with carefully graded areas of solid tone. Removing your hallmark style can also create an almost photographic effect. (Pencil)

FREDA

MOIRA CLINCH

Broad blocks of tone capture form in space fast, making simple but effective drawings of transitory subjects. Here, torn areas of tracing paper are "toned" with different grades of pencil. These are then put together as a collage – this limits the artist to thinking only about depicting tonal areas rather than worrying about linear details. (Pencil on torn tracing paper)

relative positions, thus setting the limits of the tonal range in the drawing. All other variations in tone must be graded between these two poles. Pay special attention to the lighter areas that are sometimes reflected on the shadowed parts of forms. Your brain tends to interpret these as lighter than they are, making it easy to allocate too light a tonal value to them. Because they are in a shaded area they are lighter darks, and cannot be as pale as the values in the light. Conversely, any darker areas on the lit side are darker light values, and will not be as somber as those in the shade.

Still Life: Pen and Ink

A STILL LIFE is a good way to study tone. With a static subject, there is no time limit to worry about when building tonal strength, and you can experiment with different ways of darkening the paper. A dip pen and ink, offering the possibilities of hatching, dotting, and stippling, gives you scope for a personal response to mark-making; reed and bamboo nibs are the most versatile. Remember to make random marks on scrap paper first, as well as thumbnail sketches. This gives you the chance to check how long you can draw between dipping, how long it takes hatching to dry before you can crosshatch without creating runs, and how much you can dilute the ink.

Materials

Hot-pressed watercolor paper, or smooth acid-free drawing paper • Brown ink • Container for dilutions • Reed or bamboo pen, or dip penholder with drawing nib

Thumbnail Sketch

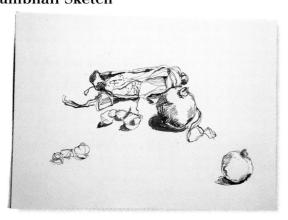

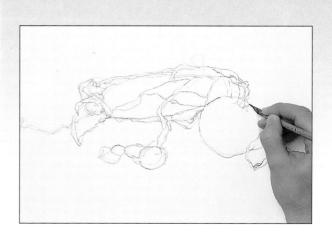

Plan the layout

Set up your group with side or back lighting, to create cast shadows for richly toned areas in your subject. Bamboo or reed pens make expressive marks, but choose a smooth paper finish, as inflexible nibs only touch the tips of rougher textures. Using diluted ink initially will allow you to make corrections in stronger tones later, making alterations easier. Evaluation is more difficult, however, as the dimensions may not look right without tone — even if they are — so start shading once their positions are fixed.

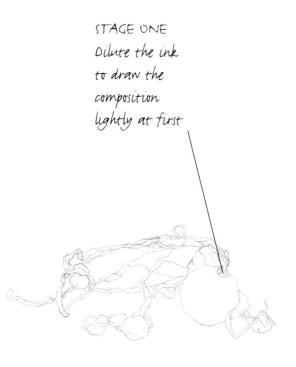

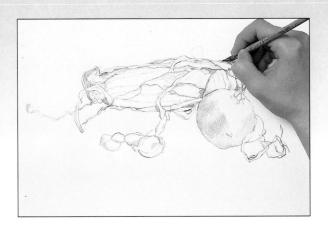

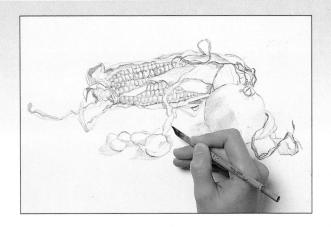

Develop tone evenly

Build up tonal strength gradually with diluted ink, in case you need to make changes when the dimensions appear more clearly. If you plan to draw tone by crosshatching, practice on scrap paper until you see how long the ink takes to dry, which depends on the ambient temperature; the hatching will be crisper if the first shading is dry before you work across it. Always keep tonal development even throughout, not finished in isolated patches.

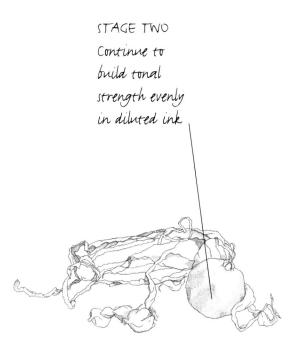

Emphasize and reinforce structure

Overlapping tones appear darker, so when you have verified your composition and proportions, begin reinforcing the lines and tones you want to give extra weight and emphasis, or those that are tonally strong. A drawn line always denotes the boundary between two disparate tones, even if the difference in gradation is small. Showing color changes of exactly the same tone is optional as a line only, otherwise, when you draw a line, put in the tone that goes with it.

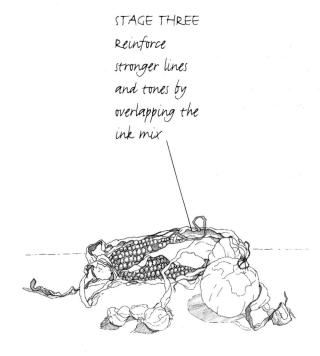

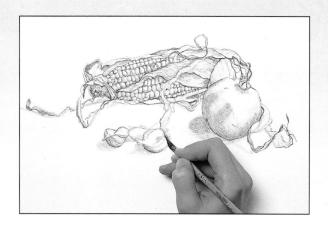

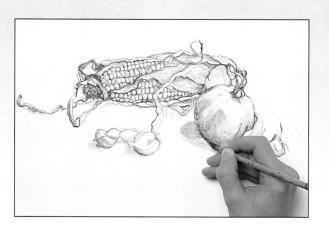

Evaluate and intensify tones

Continue building the tonal strength, using direct observation to determine the density required. Stand back from your drawing at regular intervals, to check that the tonal scheme is achieving the right intensity. There is scope for making expressive marks in pen drawing, and a personal response to the task of toning the paper gives your drawings individuality — the only criteria for your tonal marks are that they darken the paper to the right degree, and in the right area!

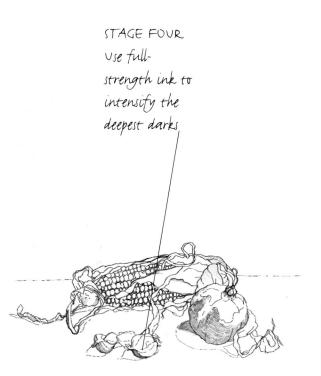

Draw the subtle values

Add the fine details, such as shadows in leaf veins, and the smallest indentations and changes in contour on the forms. Resist the temptation to shade round objects in a circular direction; you are unlikely to represent the curvature accurately, and may misrepresent by flattening the object. The intensity of tone, its location, and the hard or soft quality of its boundary as you observe it, are what create the illusion of roundness, whether your shading is hatched, flat, stippled, or solid.

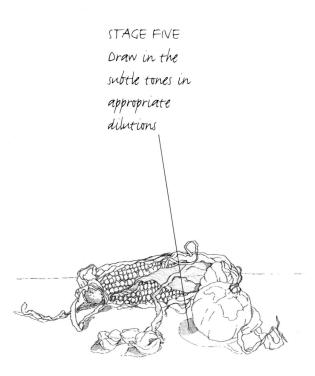

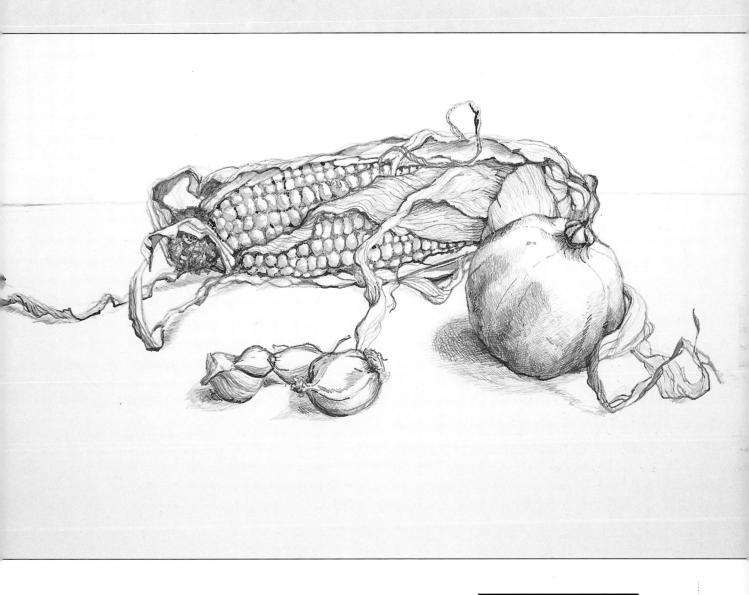

STAGE SIX
Subdue
over-bright
highlights
where they
are obtrusive

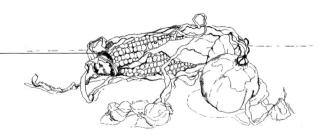

CORNCOB

JULIE JOUBINAUX

There is always a danger that a drawing built up gradually over a sustained period of time will become so packed with a wealth of information that it becomes hard for the viewer to take in. Remember that values are quieter within cast shadows, and much detail can be shown slightly obscured and less obtrusive inside the dark tonal areas. Make sure that you employ selectivity about what is emphasized, because stressing everything with equal weight gives no direction to the viewer.

Landscape: Pencil

THE TONAL CHARACTERISTICS of a landscape can alter dramatically as seasons, weather conditions, and time of day change. Drawing the same view at dawn and dusk can produce very different results, due to shadows and light sources shifting. It is important to work quickly so that you can record the light at one single moment of the day with accuracy. A wide variety of tones can be achieved with the sensitive adjustment of touch, marks, and shading available from a single pencil, and with the use of an eraser to expose the paper's white surface. Find a viewpoint that provides an interesting blend of light and dark features to create a lively and contrasting scene.

Materials

Acid-free white cartridge paper • 2B pencil • Plastic eraser

Thumbnail Sketch

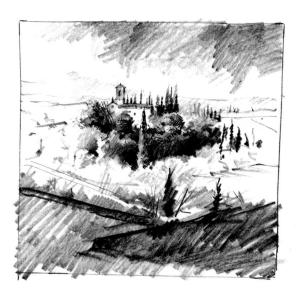

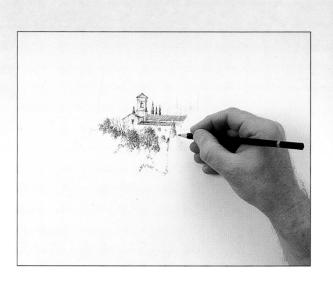

Introduce main features

Starting from the center of focus — in this case the tower of a chapel among trees — outline the main areas. This needs little more than the line created by the weight of the pencil on the paper. Applying too much pressure now can cut down the range of tones you may need to call upon later, leaving the overall image too dark. As you work, emphasize these light touches when you are satisfied with their position.

STAGE ONE
Outline the
main features
lightly

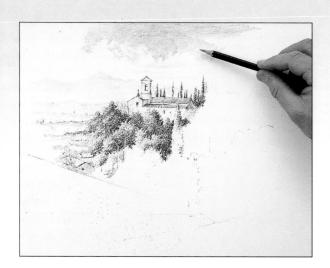

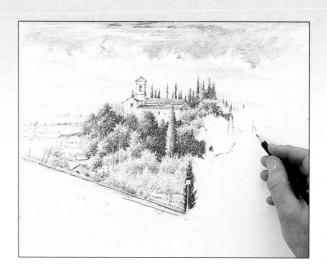

Develop the composition

Keeping the pencil sharp — turn it in your hand every few minutes to maintain a point — work on some of the lighter areas, such as the sky. There is a surprising variety of tones here, too, and by using the side of the pencil you can create a contrast with the foliage. The trees can be created from a series of small marks, rather than by shading. Aim to find marks that are recognizable as different species of trees.

STAGE TWO
Use a variety of
marks to build
up larger areas

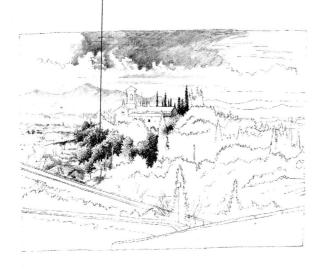

Contrast tones

The central band of olive trees requires soft marks to make it stand out against the darker trees behind. The hills are lightly shaded in the background. Stand back from your work at regular intervals, to get an overall view. Light conditions and cloud formations will change if you are working over a period of hours or days, so do not commit yourself to dense tones too early in the drawing.

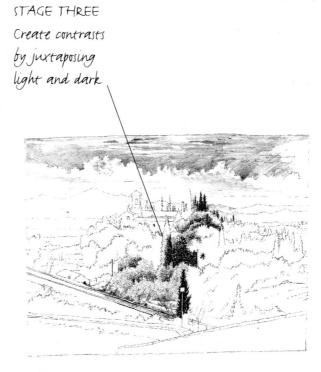

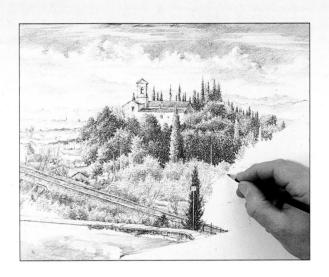

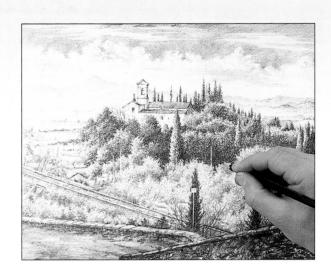

Shade light features

The tonal values needed in different areas become more apparent as the picture develops, and you will find it necessary to return to areas that you have already worked on to make adjustments. The darker tones around the clouds in the sky can be picked out with soft shading that leaves no sign of individual pencil marks. If you are right-handed, you will find that working across the paper from left to right will help to prevent smudging with the back of the hand – and vice versa for left-handed artists.

STAGE FOUR
Build up the
tones with a
light touch

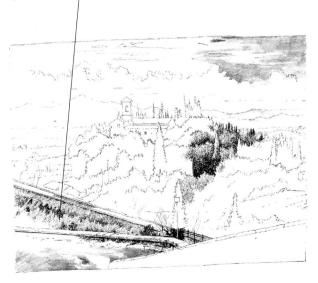

Draw a variety of marks

A shadowed foreground with little to offer in terms of details can take broader, denser strokes of the pencil, thus highlighting the lighter elements that surround it. A variety of marks prevents the drawing from becoming lifeless or too one-paced. Each new tonal area you work on will affect the ones immediately around it, so make sure that you look at, and work on, the drawing as a unified whole. As you become satisfied with the tonal values required, continue to make bolder, more confident marks.

STAGE FIVE
Develop darker
areas to create
a sense of depth

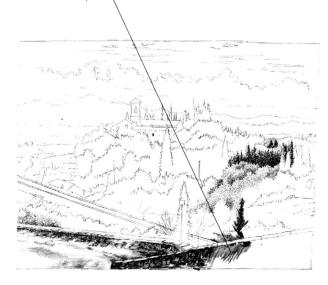

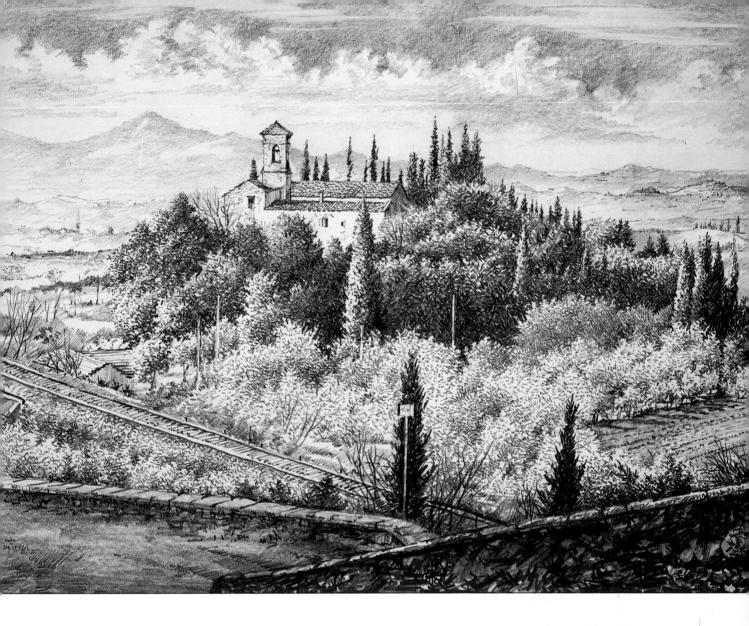

STAGE SIX
Complete tonal
relationships
with final
adjustments

SAN VITTORE, TOSCANA MARTIN TAYLOR

Having completed the entire surface of the paper, the next stage is to finalize the tonal values. The sky has been softened slightly with an eraser, and some form has been given to the hills on the left by rubbing back to the paper surface. If the drawing has taken several hours, check for consistency in the way the light and shadows fall. You can now commit yourself fully to darkening shadowed areas with firm marks, to create a consistent whole.

Gallery

TONAL DRAWING MAY SEEM challenging at first, because you need practice in order to feel comfortable making a graded range of marks that darken the paper appropriately. As you become accustomed to the speed and intensity of each medium's expression of tone, and the pressure required to vary the intensity, consider the visual quality of your marks. Even, linear hatching creates a calm atmosphere, while dots, dashes, and random marks are livelier. Experiment to discover different effects.

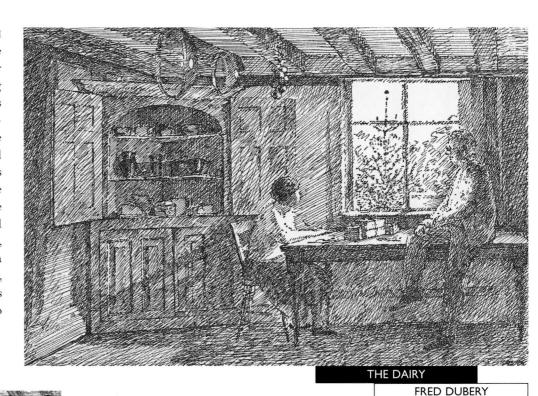

Attention points

A quiet, domestic interior, with figures sitting together companionably, calls for a treatment that reflects the harmony and tranquility of the situation. Orderly, single hatching with pen and ink at subtly varied, sloping angles, with crosshatching to provide extra depth, is an expressive solution. There is ample opportunity to create variety by breaking, dotting, or reinforcing lines, and by allowing the hatching to approach solid cover in the darkest areas.

- Pay attention to perspective when making your initial statement. Interior views are easy to handle if viewed simply as a box form, drawn from the inside. Remember that the elements overhead, the ceiling and beams, appear to slope downward as they recede. The floor below appears to slope upward, while the verticals remain constant. The stronger tones in the deep recesses, and corners farthest away from the light source, enhance the three-dimensional effect.
- 2 In the early stages of a pen drawing, apply tone lightly throughout. Pen work is hard to erase, but early changes can be hidden by reinforcement if your initial statement is made with lighter pressure.
- 3 Accumulate tonal density gradually, and develop the whole drawing evenly. Focusing on one area at a time reduces your flexibility, and impairs your ability to define dimensions correctly.

- 4 To create a quiet, tranquil mood, hatch in long, gently sloping strokes, near to horizontal.
- **5** Shorter strokes nearer to vertical make for a livelier, more intense and contrasted effect.
- **6** Simplicity is essential for retaining a calm atmosphere, so keep detail to a minimum, or lose it in shadow.

Key Planning Points

- Organize the tonal scheme with the richest darks on surfaces turned away from the light, and the brilliantly lit areas free of ink
- Emphasize tonal contrasts slightly at the center of interest; in this case, the two figures and the window

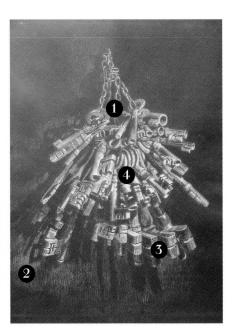

Attention points

The gleam of a key chain, spotlit against a somber background, creates a dramatic effect by eye-catching contrast. Equally dramatic effects can be achieved with the opposite formula of dark objects against light, such as trees against a sunset sky. In both cases, superficial detail is eliminated in the overall tonal effect, and the silhouette shapes become more significant. Here, where the majority of the values are dark, white pencil is used on dark brown paper.

- O Shown pale against a dark ground, the composite shape of grouped objects becomes clear. Look for unifying factors, such as the underlying chain securing the keys. This must be correctly implied to draw the keys in perspective, and is best considered from the start.
- 2 Strong lighting creates heavy, cast shadows, close in tonal value to the background in this example, and indiscernible at a glance, making them difficult to see as you work. Avoid confusion by showing the faint gleam of the backdrop that is slightly brighter than the cast shadows.

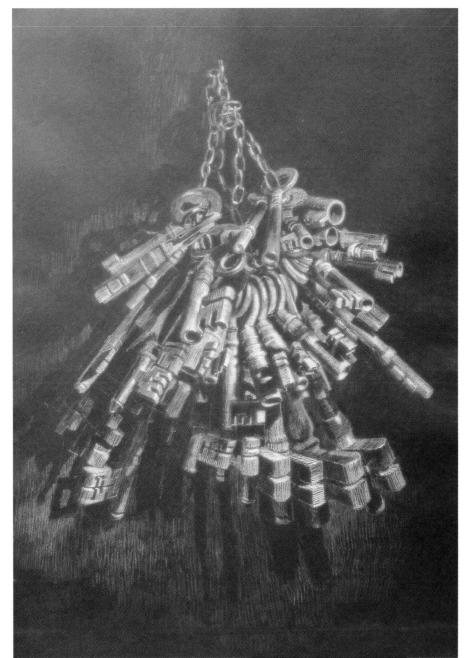

MICHAEL WOODS

A BUNCH OF KEYS

- When working from light to dark, grade the intensity of the pale values in the same way as you would organize the rich tones in a dark medium. Intense light penetrates even dark clefts, so observe the tonal value of faceted surfaces carefully.
- Metallic surfaces show gleaming highlights, so draw them with the correct intensity of tone.

Key Planning Points

- When depicting a smaller, bright area against dark values, save time and effort by drawing with light media on a toned ground
- Consider the overall shape, in this example a triangle, when laying out the composition

Color

Many students of drawing are reluctant to begin color work because they anticipate difficulties. In practice, making colored

drawings is easier than most people expect it to be; in monotone media, you are obliged to allocate a tonal value to each color, in order to represent it, but in color, you simply draw what you see. Mixing colors to match observed values becomes less daunting when you choose a palette with sufficient range to create all your required shades.

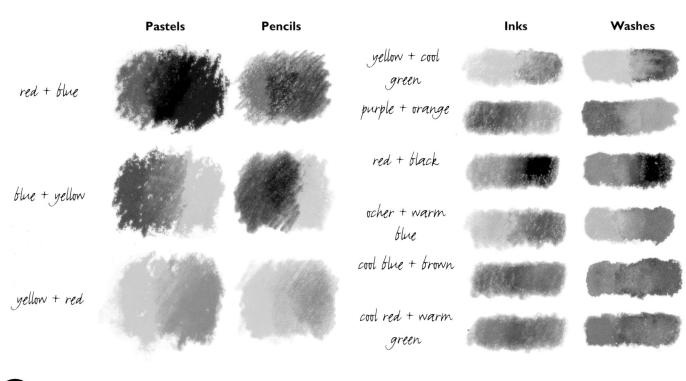

HERE IS NO hard-and-fast boundary between drawing in color with a brush and painting, but most colored drawing media are used dry. The difference is in the mixing methods: except for washes in ink, pre-mixed colors are painting media that can also be used for drawing. Those mixed on application are drawing media, and only lend themselves to a kind of dry-painting method if areas are covered broadly with color, as with paint.

A relatively small range of colors is needed for pre-mixing, because the permutations that are possible create many variations of hue. The surface mixing required in dry drawing media,

These samples show the colors created by mixing primary colors.

such as pastels and colored pencils, is less easy to accomplish. Because such linear media make narrow marks, adopt an accumulative technique, such as hatching or crosshatching, to build up a body of color. Strokes applied separately will be seen as a composite shade at a distance.

Overlaying color creates mixtures, too, and this can be built up to strength gradually. Experiment beforehand to warmth or coolness in colors will influence mixtures.

The degree of

discover the colors that result from changing the order of application: for example, a different purple is made by applying blue over crimson from the one that is made with crimson over blue. Complicated color mixtures can be dulled by the traces of hidden colors they contain, so to be truly effective, keep blends as simple as possible.

A good palette for making premixed colors in either inks or washes

69

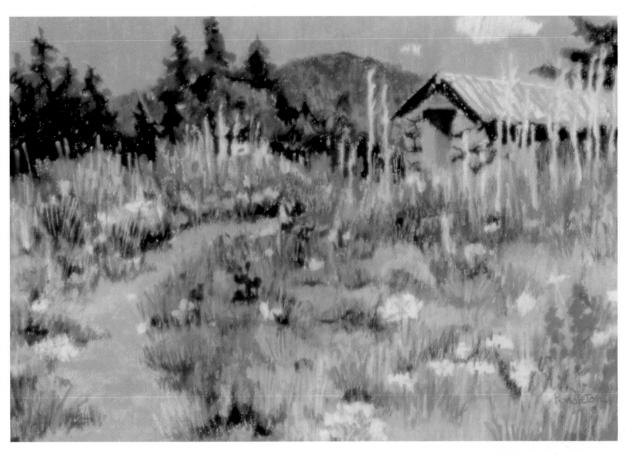

comprises: opaque white, for lightening and creating pale shades, unless you use diluted transparent colors for this; mid-yellow, of the type called egg or sunshine; orange-red, for making orange and light browns; crimson red, for mixing mauves and purples; warm, dark brown, for a mixing base for browns; cool mid-green, for a similar base for greens; mid-blue, usually called cobalt, that makes turquoise when mixed with green; warm, dark blue, usually called French ultramarine; black, both as a color and to make greens with yellows, and browns with reds.

This list can be expanded for drymixed media, so that you can create rich shades without making them muddy. Add dark earth yellow; strong orange; dark earth green; ready-made purple; cold, dark brown, leaning toward green; warm and cold grays. Make a color card of all the mixtures you can create, to remind you of the various recipes until you are able to recall them spontaneously.

BETSY'S RETREAT

PAT PENDLETON

Asymmetry works better than balance in color compositions. Allow warm, red- or yellow-dominant colors, or cool, blue-based colors to predominate over a smaller quantity of opposing values. The blue and green of the sky and foliage here are offset by a lesser quantity of hot, earth colors and red, pink, and yellow blossoms. (Oil pastel)

HOT TUB NO.11

KITTY WALLIS

Separate strokes of pure color can be applied in a dry medium, such as soft pastel, calculated to be seen as mixed colors when viewed from an adequate distance. Optical mixing produces rewarding effects once you have experimented with color combinations and scale of marks, and are able to calculate your results with accuracy. (Pastel over an acrylic underpainting)

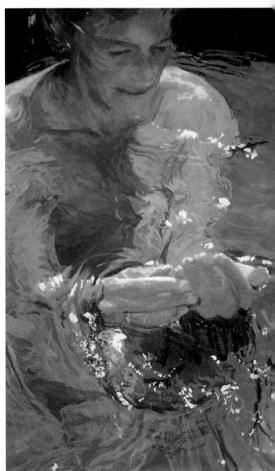

Still Life: Aquarelle Pencils

NATURE OFFERS THE artist a myriad eye-catching and enticing subjects. However, working outdoors can prove problematical, with changeable weather and lighting conditions altering colors and shadows as you draw. The perfect start for the inexperienced artist is a still life of colorful natural objects, such as fruits and vegetables, that can be set up at home easily. Work from the same side as the light source, so that the objects are fully illuminated and display maximum color. Make a quick, monotone sketch, using simplified shapes and tones, to establish the design.

Materials

Hot- or cold-pressed (not) watercolor paper, or acid-free drawing paper • Selection of aquarelle pencils (see page 68 for color list) • White gouache • Plastic eraser • Large flat brush or mop brush • Detail brush • Small sponge • Gummed paper tape

Thumbnail Sketch

Block in color lightly

Block in the larger areas of color, freely and lightly at first. Use the pencils dry, as this keeps the drawing flexible for as long as you need to make adjustments. Drawing faintly means that you can make amendments with an eraser, and juggle the objects into their correct positions if necessary. If the emerging design is not what you wanted, be prepared to amend your viewpoint or the arrangement for a better result.

STAGE ONE

Position the objects with lightly shaded dry color passages,

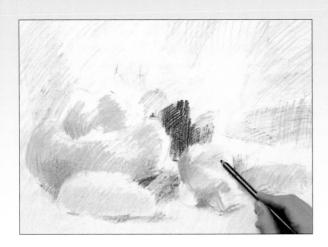

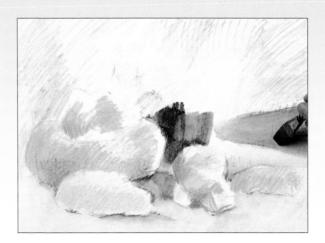

Intensify the colors

Begin to build up color strength, again using the pencils dry to block in the solid shades that establish the form of the objects and their surrounding spaces. Bear in mind that the colors you apply will be refined and adapted by later wash overlays, so concentrate on completing the basic colors, so that you can evaluate the present values against each other. Make sure you shade right to the edge of your image.

STAGE TWO

Use dry overlays to create color mixtures and increase intensity

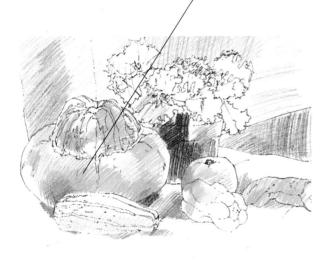

Consolidate with washes

Brush on washes of clean water, to blend colors or set their values. This happens when the water takes color pigment with it as it sinks into the paper, so check the results at once, before it dries. Unsatisfactory washes can be blotted off, provided you remove them fast, as they set quickly. Do this as an emergency measure only, because it sacrifices freshness if repeated.

STAGE THREE

spread washes to eliminate unwanted traces of white paper

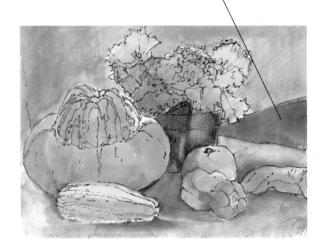

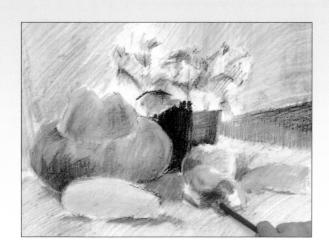

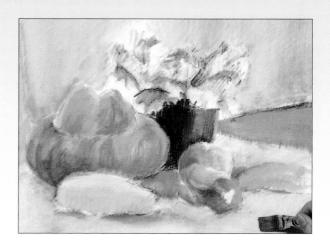

Work with color contrasts

Allow the washes to dry, then adapt the color values using dry pencils. Remember, colors are affected by those adjacent to them — for example, red appears less bright in the company of other red hues, but stronger against green, its opposite — so take this into account when color matching. Work cleanly in areas where you want fresh color; a thin veil of the opposite color will subdue any over-bright values.

STAGE FOUR Enrich and adapt colors with dry pencils

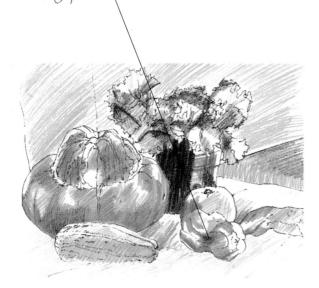

Strengthen the shades

Again using clean water, brush the blends of colors to create the more subtle mixtures. Unless you are seeking a deliberately brash effect, you must capture shades, which may be dark, dull, muted, bleached, or obscured by strong light or shadow; in some lighting conditions, these areas can constitute most of a drawing. Wash and overlay the colors until these unobtrusive, but vital, parts make a counterpoint to the brighter hues.

STAGE FIVE

Blend the dry overlays with clean water

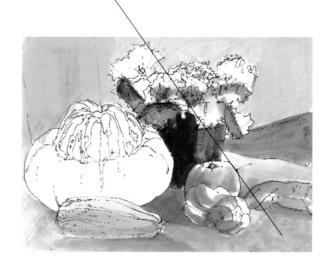

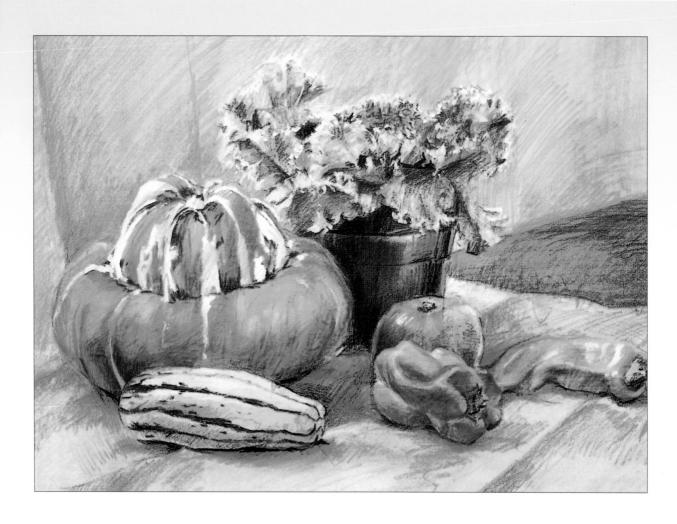

STAGE SIX

Refine the drawing by adding selected color details more sharply

PUMPKIN

IAN FELLOWS

Finally, check the tonal values of the colors, remembering that red is bright but has a dark tone. If necessary, use tube white gouache to re-establish lost pale tones, such as the banding on the pumpkin. If the rich shades lack intensity, draw straight onto a previosly damped surface to apply denser colors, but note that these are permanent, as the concentrated pigment is a powerful stain on the wet paper.

Portrait: Oil Pastel

THE CONCEPT OF color temperature relates to personal experience. Colors in the red, orange, and yellow range are generally seen as warm, while blues and greens are considered cold. Take care that preconceptions do not impact on your drawing. In portraiture, for example, knowing that your sitter is alive and warm may predispose you to expect flesh colors. In fact, the shades observed are subject to lighting conditions that may be cold or hot; and the skin color of the sitter is in turn dependent on age and race. Use oil pastels and oil bars for easy mixing, with turpentine if you want smooth blends.

Materials

Hot-pressed watercolor paper, or smooth, acid-free drawing paper •
Selection of oil pastels (see page 68 for color list) and oils bars, if used •
Turpentine or mineral spirits • Small, filbert bristle brush, or clean cotton rag wiper • Craft knife

Thumbnail Sketch

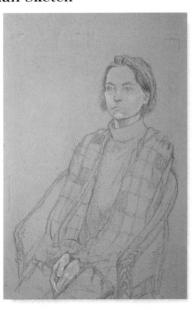

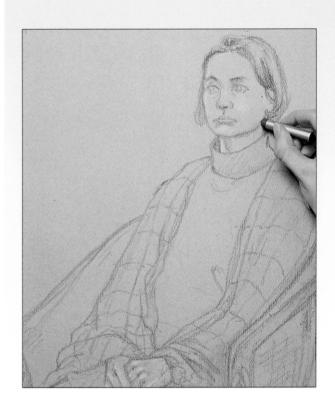

Define the pose

Select an attractive, neutral-colored paper, and draw the pale values in addition to the dark tones, to help you gauge proportions and dimensions. Oil pastels cover the paper easily, and soon saturate the surface, so keep applications to a minimum until you have confirmed placing, perspective, and negative shapes by comparing these to the sitter's pose.

STAGE ONE
Use both
dark and
light pastels
to draw the
proportions—

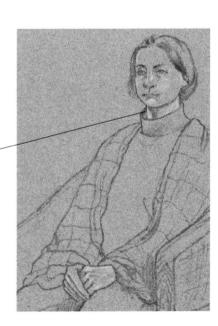

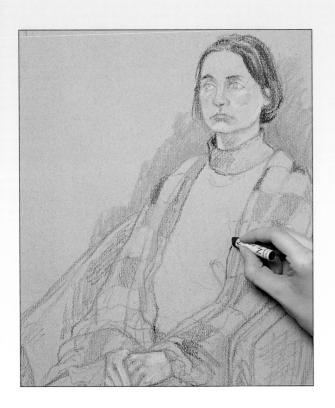

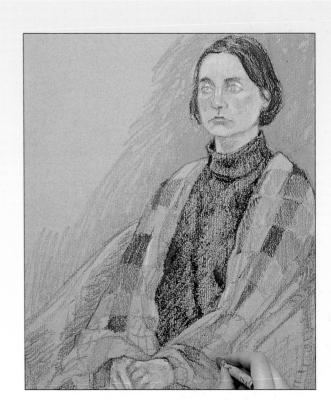

Compare relative color values

Take account of the background and garment colors as well as the skin tones. Color tones and temperatures can only be assessed in relation to each other, so establish new values against existing colors. Make regular checks, and if a color seems unmatched, adapt your mixture before going further, or you will build on the error.

STAGE TWO
Introduce the
main colors,
drawing
with light
pressure

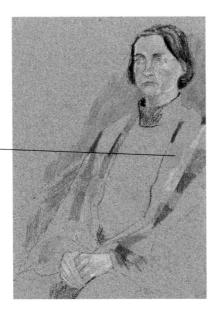

Establish the main colors

Apply colors lighter than you intend them to be finally, to allow for corrections. Include any patterns on clothing, as these are an invaluable aid in helping to describe the form of the wearer. You may not have a likeness at this stage, but keep up progress on the portrait head, adding color to skin tones and beginning to define the features.

STAGE
THREE
Cover all the
major areas,
still pressing
lightly

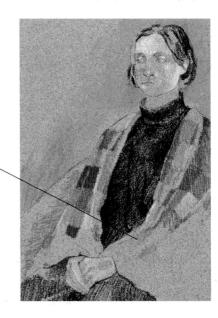

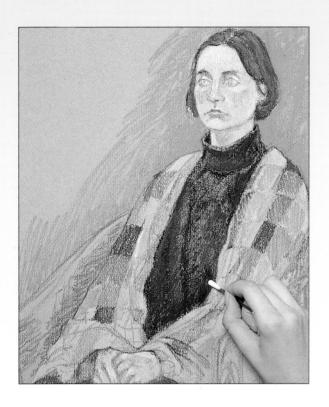

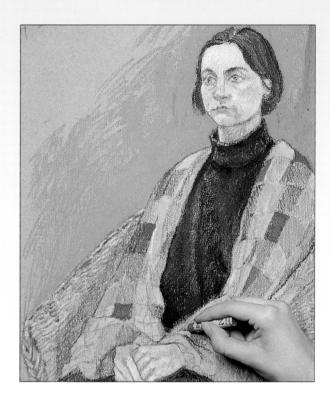

Apply a denser cover

Bring the main elements up to full tonal strength by applying a thicker color coating. If you need to make changes, wipe off existing pastel deposits with turpentine on a rag. Use this technique for surface blending too, but with less pressure. For blends in small areas, use a cotton swab or brush moistened with turpentine.

STAGE
FOUR
Blend pastels
with
turpentine
to mix or
consolidate
the colors

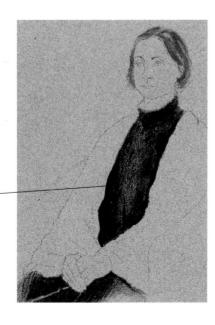

Unite the color scheme

The minor elements that are not yet up to full strength of tone and hue need unifying with the color scheme. You can transpose color values to brighter or quieter shades, or darker or lighter tones, as long as you do so throughout, preserving the same relationships between the colors. Altering values unequally will result in chaotic distortions.

STAGE FIVE
Draw in the
finest
details, most
intensively
in face and
hands

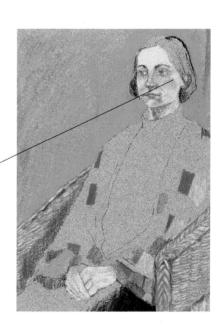

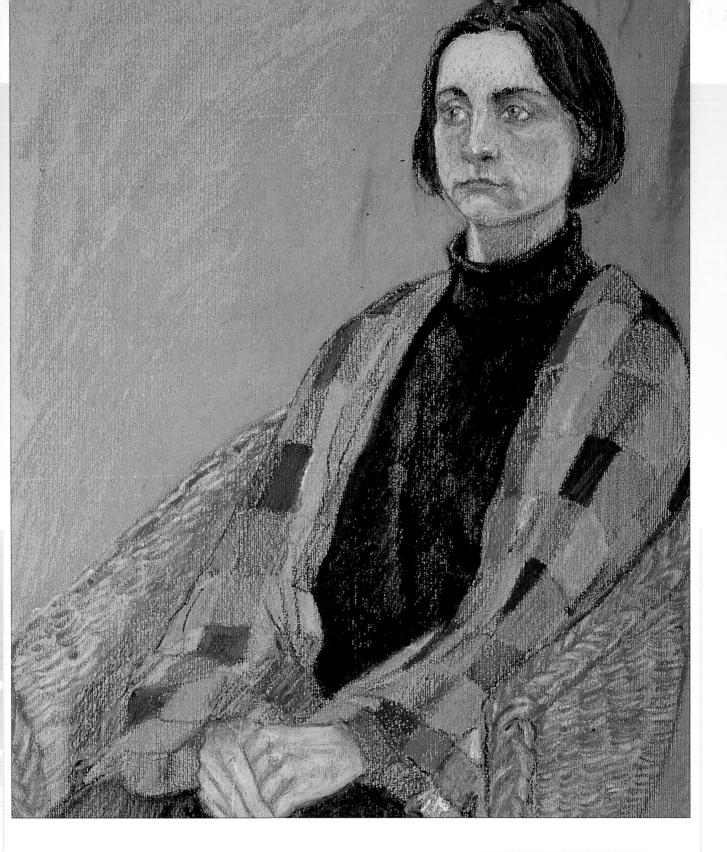

SEATED GIRL

DEBRA McFARLANE

The eye will be drawn to any highly worked element, so concentrate the most intensive color details in the features, then the hands, and then the clothing. The background must be rendered plausibly, but keep the colors marginally less intense.

Gallery

COLOR CONVEYS MANY different elements, including the anecdotal details of local shades, and the overall color bias of time of day, season, and location. It also evokes an emotional response: quiet colors will soothe, and bright, singing colors will energize. Take this into account in your planning, and choose a view, or include elements, in order to create a desired mood.

If you have little experience of color mixing, working with an extensive range of colors can seem confusing. Add colors to your palette in phases, starting simply with the three primary colors, red, blue, and yellow, with the addition of black and white. From these you can mix secondary colors; add more shades once you have become accustomed to using the primaries. A range of aquarelle pencils are used here.

Remember that asymmetry has visual appeal, and choose a preponderance of bright colors tempered by a few quiet shades, or calm, neutral values contrasted with smaller amounts of jewel-like clarity, as in this drawing.

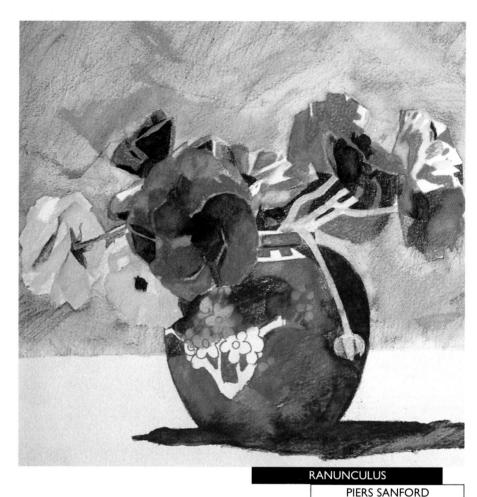

- 2 Similarly, choose a majority of either warm or cool colors, rather than an even balance, to give impact to your drawing.
- 3 Even bright colors will appear dim in deep shadow, but black alone will not create the right color. Unless the shadow is so dark as to be impenetrable, shadow colors are richer, deeper versions of the same color in light.
- 4 Colors may appear bleached when seen in bright light, and highlights on glossy surfaces reflect the light and its color, usually white.

6 Note the effect of color location. The blue vase is in harmony with the background cool grays, but the red and yellow show up by contrast.

Key Planning Points

- Use a limited palette to create unity in the color scheme
- Represent the tonal values of colors appropriately
- Check shadow colors carefully they are more likely to be rich than dingy
- Keep bright color mixtures clean

COLOR

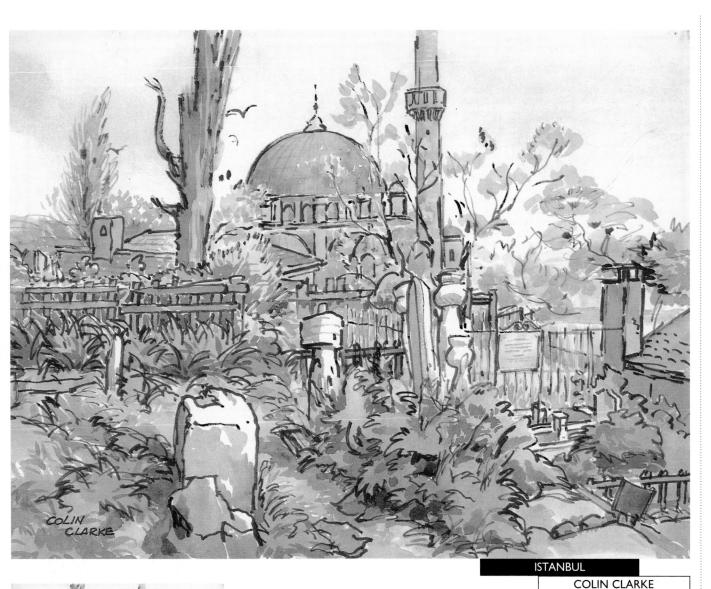

Attention points

The overcast weather in this pen and wash drawing is portrayed by using a predominance of softer, cooler colors.

Distance has the result of muting all colors, due to the filtering effects of dust and moisture in the atmosphere. This is aerial perspective, which creates the illusion of distance by color values alone.

Often, the majority of colors that you require will be subtle or indeterminate hues that create a mood such as that evoked by this soft, verdant view of a distant landmark. Cool grays and greens can be offset by smaller measures of warm orange-pinks and rusts.

2 Grays are not mixed using black and white alone; useful shades are made by adding many colors, including blues, browns, and greens, to a basic gray, or by blending blue and brown with white.

3 Flashes of brilliance, such as white stonework reflecting light, will enliven an area where quiet colors might otherwise appear drab.

4 Use darker colors on items silhouetted against the light, as these will

appear to be in shadow.

Key Planning Points

- Stretch your paper before wash drawing
- Make pen or brush lines in waterproof ink or watercolor: these set when dry, and are not disturbed by subsequent washes
- Distant colors should not be as bright as those in the foreground

Pattern Texture

Apart from their enjoyable decorative qualities and their role in describing form, emphasizing pattern and

texture is one of the best ways of organizing a complicated subject. Seen in common with several objects, a strongly

> patterned fabric or textured background can be a unifying factor.

Drawing a group of items with similar surface textures, that make a link between them, helps you to depict a wide assortment of visual qualities in a cohesive way.

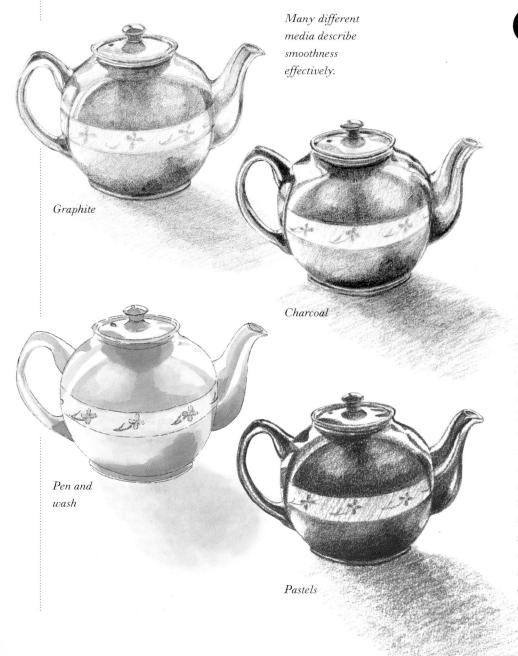

ATTERN AND TEXTURE create much of the surface interest on the forms you draw; if you decide to feature them, you must choose beforehand how you will treat them. The choices range from the literal and anecdotal, which is decorative but laborious to execute, to the impressionistic, where key qualities are rendered in a simplified way. Use lighting to assist you in heightening or simplifying effects: for example, a raking light shows up texture to advantage, while heavy cast shadows obscure large areas

of busy pattern. Choose media that depict different aspects of pattern and texture well. Pastels and carrés make crisp marks to represent the complexities of pattern, and have the breadth required to achieve a range of different textural effects. Pen work is a source of varied, expressive marks to depict texture, and has the flexibility necessary to render any patterned effect, from brash to fine. Charcoal has the advantage that it can be easily erased if you need to adjust a tricky pattern, and graphite, the perfect flexible medium, can convey both pattern and texture with subtlety. If you have any difficulty in deciding what to show, stop drawing and look carefully until you have devised the right response to render the effect you want.

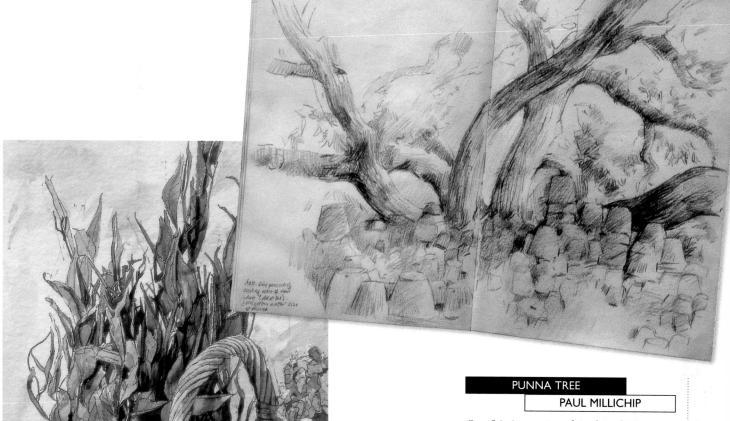

Careful observation of the fall of light across the surface of a texture such as rough tree bark will suggest a suitably representative mark, so long as you are open-minded and innovative about markmaking. Be prepared to make several sketchbook studies, not necessarily highly finished drawings, while you explore the effects of various textural marks. (Pencil)

DRIED FLOWERS IN A BASKET

MICHAEL WOODS

Many subjects offer the opportunity to combine studies of pattern and texture to advantage. In this decorative study, the formal pattern of the woven basket, with the smoothness and regularity of its cane construction, are well paired with the asymmetrical, random patterns of matte blossoms and leaves seen against a clear space. This provides a foil for the busier, interest-packed areas. (Pen and wash)

One possible approach is to base your response on your natural vision. Wide areas of pattern or texture are not seen needle-sharp but more generally, with smaller areas that are seen more clearly when they are in your main field of vision. The field of vision we see is cone-shaped, with the center of the cone in sharp focus. At arm's length, the focused area is only the size of a thumbnail. In order to see clearly on a wider scale, you scan constantly from a moving vantage point, not stock-still.

Because peripheral vision is vague, pattern and textures away from the center of interest can be dealt with more broadly. It is not necessary to attempt to convey every detail of a complicated texture or pattern to achieve representative effects, but a vignette with blurred edges can lack credibility. Select what you want to emphasize in conjunction with your three-dimensional design, and remember that areas of pattern and texture that are developed in detail will become eye-catching centers of interest.

Still Life: Pastel

A STILL LIFE is the best way to begin looking at the uses and effects of pattern and texture. Choose items for their textural appeal or the pattern they possess or create, according to how you place them. For contrast, assemble the group with an eye to the differences as well as reinforcing the similarities. Pay special attention to the way you light the arrangement. Natural daylight or directional lighting give good results, but multi-directional lights diffuse shadows, and can make textures harder to discern. A jumble of patterns can be difficult to resolve in a drawing, but it will be manageable if cast shadows subdue much of it. Soft pastel is an excellent medium when allied to pastel pencils for finer marks.

Materials

Cold-pressed (not) watercolor paper, stretched and tinted with neutral wash, or acid-free, neutral-colored pastel paper • Selection of soft pastels (see page 68 for color list) and pastel pencils, if used • Stump or wiper • Kneaded eraser • Fixative • Gummed paper tape

Thumbnail Sketch

Create a minimal structure

The charm of soft pastel drawing depends on fresh handling. Fussy treatment loses the beautiful opalescent effects caused by light reflecting on the particles of pastel dust, so draft your initial sketch minimally, to avoid loading the surface with dust in the wrong places. Choose paper with sufficient texture to hold the dust, but avoid the roughest surfaces unless you are content with broken cover, or are prepared to push the pastels into the tooth of the paper with a brush or stump.

STAGE ONE
Press lightly
while drawing a
minimal basic
structure

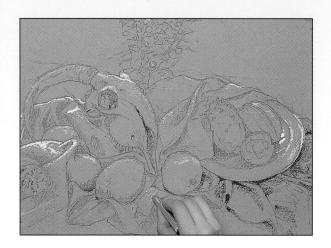

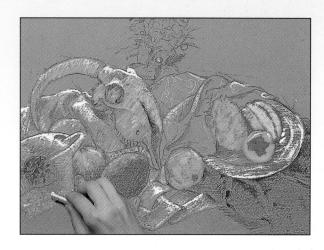

Set the tonal limits

For subtle pattern and texture elements, organize your group so that the items make a pattern in their arrangement, and highlight textures with a raking light. Fix the position of the brightest light tones at the same time as you draw the darkest values; they are equally important, and will establish the tonal extremes. The fall of light across objects reveals surfaces as well as form; draw major shadows in the most deeply defined textures.

STAGE TWO
Set the deepest
dark tones and
brightest light
values

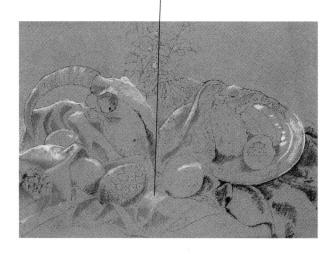

Introduce textural contrast

Some textures are defined by the reflection of light on their surfaces, while others are characterized by diffused effects. If your group contains a plant or cut flowers and leaves, determine which method you use to represent these by considering the other items and the interpretative possibilities they offer. If the majority of the arrangement consists of solid objects, deciding to draw the plant material as a broken texture that diffuses the light will provide a contrast and offset the dominant element.

STAGE THREE
Establish the
basic colors, and
begin to define
patterns and
textures

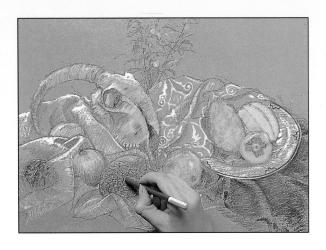

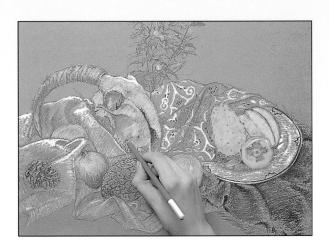

Draw pattern in perspective

Do not leave out patterned surfaces, such as fruit, fabrics, or ceramics, for long; the decorative element of pattern is a force to be reckoned with when composing a design and selecting areas for emphasis. Be careful to draw the pattern in perspective, particularly when it follows the circular contour of a piece of ceramics or fruit. Just as no round object can appear to have corners, so your drawing of the decoration on it must curve with the form.

STAGE FOUR
Draw patterns,
with particular
attention to
perspective on
curved surfaces

Represent subtle textures

One of the artist's tasks is to devise marks that represent the different substances of which subjects are composed. These qualities are often apparent as texture, and the difference between the sheen of bone, fruit, and china may be subtle and consist of tiny tonal changes. Direct observation is the best method for deriving appropriate marks, so take time to study surfaces carefully before deciding which pastel effects will best show minute textures. Pastel pencils are very useful for adding details.

STAGE FIVE
Use delicate
strokes to depict
the pattern and
texture details

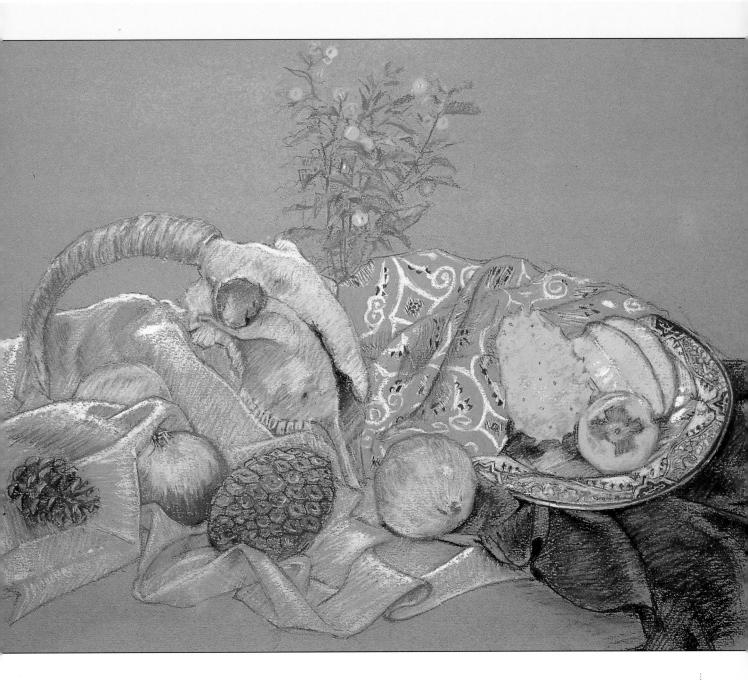

STAGE SIX
Complete the
finest details,
and apply
fixative
lightly ____

MEMENTO MORI

DEBRA McFARLANE

Evaluate the strength of the patterned elements in your drawing and intensify these if necessary, or reduce them by tapping the surface with a kneaded eraser to remove the dust cleanly. If adjustments to the contours or perspective are required, brush off surface dust carefully with a bristle brush, to clear the surface. Unless you are putting the drawing into a glazed frame to protect it, fix soft pastels lightly, or they may smear on contact.

Landscape: Pastel

THE TEXTURES AND patterns to be found within nature offer a wealth of opportunities to the landscape artist. The lines of fields and hills, the light of sea and coastland, and crops and shrubs in bloom can provide spectacular, colorful subjects. Quite often the textures and patterns need to be drawn out – you can use colors creatively to produce an imaginative drawing, rather than being limited by what you see before you. The marks you deploy also contribute to the patterned effects you can produce. Because pastels are light and portable, with a wide range of colors, they are excellent for using out of doors.

Materials

Sand/flour paper • Selection of soft chalk pastels (see page 68 for color list)
• Stump or wiper • Kneaded eraser • Fixative

Thumbnail Sketch

Planning the composition

Start by planning the drawing using a white chalk pastel, making sure that all the main features you want to include fit within the dimensions of the paper. There is no need for these marks to be too detailed – they will gradually be lost as the picture builds up, but because this is the basis upon which the drawing will be developed, it is important that you are satisfied with the composition at this stage.

STAGE ONE
Draw the main
features so that
they fit within
the paper

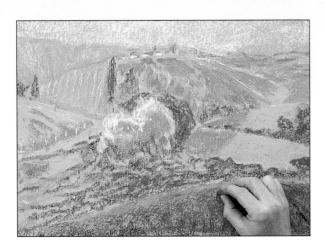

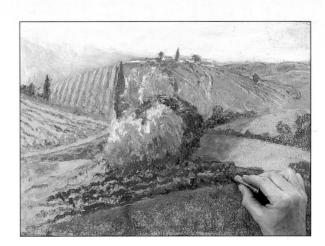

Introduce color

Color is now introduced, bringing together cool and warm shades that work together well. Creating a sense of harmony in the way the colors relate to each other is more important than slavishly following what you see in the landscape. The textures of each element grow from a variety of small marks of different colors, rather than a single pastel of the "right" color. Keep the marks fresh and your options open, so that you can develop each area, working across the whole drawing.

STAGE TWO
Build colors
gradually to
create textures

Create a sense of depth

Tonal variations across the picture plane help to give the landscape a sense of depth. The sky and distant features are lighter and have less features, but help to bring out the patterns on the horizon. Make sure that you are aware of the direction from which the light falls on the scene, and how shadows fall. Lighter details in the middle ground suggest the play of light across the fields. The original white marks have already disappeared.

STAGE THREE
Use shadows
and light
to enhance
patterns

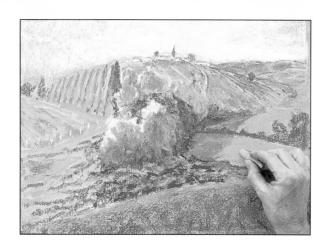

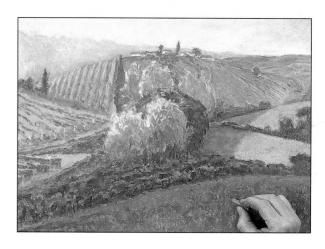

Develop color relationships

Details added to the central trees give them a sense of solidity, accentuated by darkening the shadows drawing out to the right. Keep using light touches of colors to create the textures and patterns of the fields. Other, quieter areas in the right middle ground are left to create a balance. Now, more than ever, you should be looking to create rich color relationships that will work well with each other as a unified whole.

STAGE FOUR
Reinforce key
areas to create
an overall
balance

Redefine details

The finishing details can be used to redefine areas. The red, added to the foreground with green, helps to create a sense of depth; bringing together complementary colors can add a dramatic flavor to the scene. The central trees and their shadows are given more weight. Use your fingers to mix the colors as you apply them. The last touches to the details in the background can be given greater precision by using pastels sharpened by a knife.

STAGE FIVE
Redefine color
relationships
within the
composition

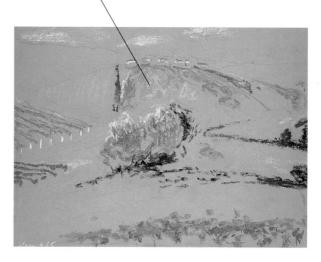

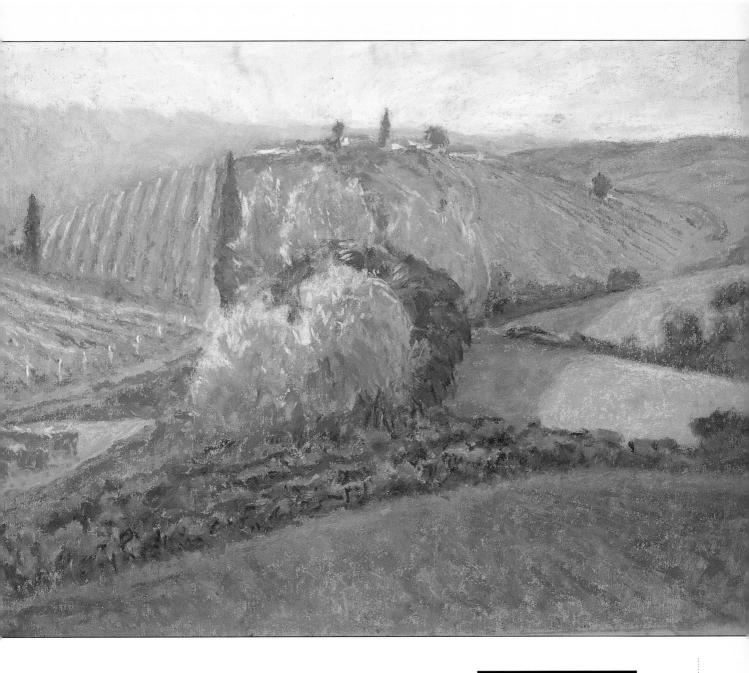

STAGE SIX
Introduce details
to focus textures
and patterns —

TUSCAN FARMHOUSES

PATRICK CULLEN

Textures and patterns within the landscape can be created by the range of marks you make, as well as changes in color. And these patterns – the stripes within fields, or the line of hedges – can be used to lead the viewer's eye across the picture. By keeping marks fresh and immediate, you can build an image in which the colors are both believable and harmonious.

Gallery

Many natural forms provide interesting combinations of pattern and texture, particularly plants. The patterns of organic growth, and the textures of leaves, petals, and woody structures, lend themselves to drawings that focus on these aspects, often also serving the useful purpose of recording a specimen of botanic interest. The best subjects create contrast by incorporating both shallow and deep textures, and ordered and random patterns. Remember to increase the contrast by including some plain areas in the composition.

Attention points

Small objects, such as the pine cones in this pencil drawing, can be shown to advantage by being grouped in a container, in this case one where a stylized leaf form on a planter echoes the theme of nature. The formal, woven, geometric pattern glimpsed beyond it emphasizes the curvilinear patterns of the cones, and the plain areas provide a respite from the concentrated detail of the subject.

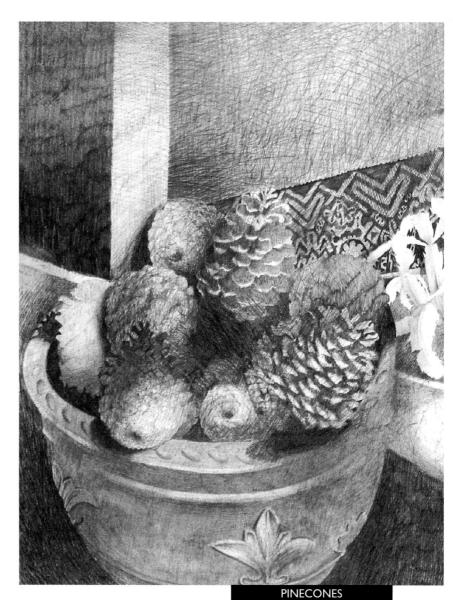

CLAIRE BELFIELD

1 Place your main center of pattern and texture interest at a point where the composition and structural elements draw the eye to it.

When protuberant objects, such as the pine spurs, are the decorative feature, use lighting to illuminate their forms.

3 Structures and textures that follow circular or spiral forms must be drawn in perspective. Map them out faintly until you have confirmed that you are following the correct curve.

4 Use tone to heighten pattern effects. The shapes of shadows cast by complex forms, or silhouetted against a contrasting ground, are important pattern elements.

Key Planning Points

- To avoid any confusion from multiple centers of interest, confine intricate patterns and textures to comparatively small areas
- If shadows obscure patterns or textures, use this opportunity to keep things simple

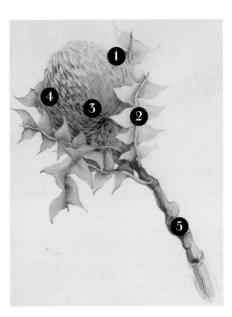

Attention points

A single plant form can contain enough pattern and texture interest to carry a drawing by itself. If your intention is to record an interesting botanical specimen, a plain background may be your best choice to avoid distraction. Tropical plants with exotic textures, or those with spiky features that make strong patterns, are excellent vehicles for a study of decorative elements. The plant in this drawing is beautifully and accurately rendered using a variety of pencils and watercolor washes.

- Choose contrasting combinations whenever you can. The broadly spherical protea bloom, with the textural interest of ovoid florets, contrasts well with the brash, sharply pointed leaf shapes.
- 2 Use pattern in the composition. Here, the triangular leaf patterns bracket the bloom, creating a larger, broadly triangular form overall.
- 3 The solidity of the plant head is reinforced by the encircling pattern of florets, while the stalks endorse the flatter pattern elements of the leaves with their twisting, linear qualities.

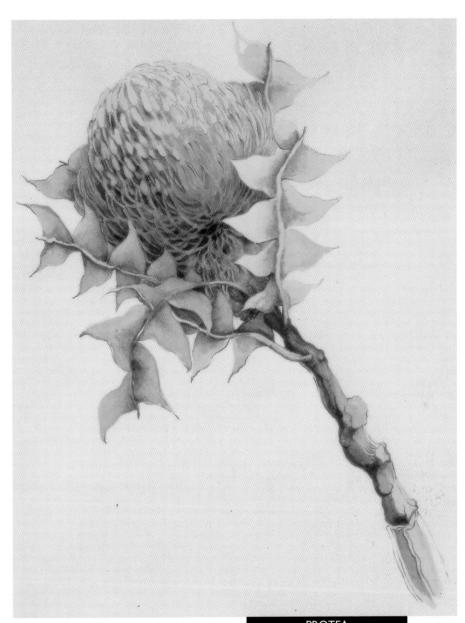

Tiny forms that catch the light and are seen against a darker ground, such as the florets, are easily defined by drawing the shadow shapes between them. Little linear elements, such as the fronds, are best picked out from a shaded area with the sharp edge of an eraser before you

6 A thick, contorted stem, with ridges and scars that contribute to the textural content of the drawing, also conveys the weight of the bloom.

sharpen the definition with a line.

Key Planning Points

GAYNOR MARSH

- Secure your specimen firmly so that it cannot slip or fall
- Choose a paper surface that will show detail well, such as hot- or coldpressed (not) watercolor paper
- Sharpen pencils to a long point for fine lines. If use has rounded your eraser's contour, cut a sharp edge on it

Line confidently. Visual memory gets better with use, and by and looking hard at motion you can fix the characteristic shapes in Movement

Rapid line drawing is useful for capturing movement. With practice in coordinating your hand and eye, you will draw faster and more

> your mind's eye, drawing from the split-

second memory. Alternatively, make composite drawings by gathering features from several moving elements. This method shows no one subject, but has the plausibility of observed action.

HERE ARE TOO many exciting subjects that involve movement for you to avoid drawing it for long. Success depends on a positive approach, so build up confidence by starting with slow and simple, repeated movements: a tethered flag, or laundry blowing in a stiff breeze, is a good example of an inanimate subject to begin with. Try drawing a friend or relative at home.

Preparing food, digging a vegetable patch, or working at a computer are all activities that involve small-scale, repeated movements by a subject who will return to similar positions time after time. Watch for a while; drawing is essentially a practical matter, and like any other task, time spent looking at the job and planning before you begin is well spent.

CHILDREN AT PLAY

JULIE JOUBINAUX

Taking your sketchbook out when you feel confident opens up a whole new range of subjects in motion. Movements are often recorded in line alone for speed, and convey the liveliness of running, playing children better than photographs. Composite drawings can be made by combining fragments. (Pen and wash)

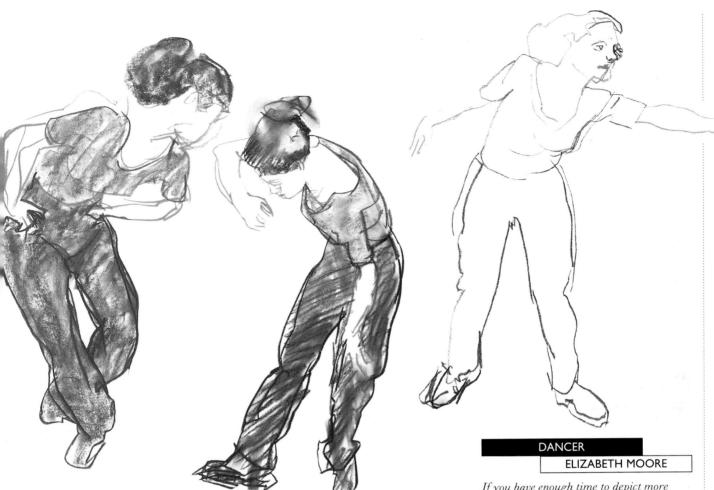

Try to analyze the main positions that are repeated in the whole cycle, and choose three or four that are resumed in turn. Allocate an area on your sketchbook page or paper for each, and begin to work on them simultaneously. No time will be wasted, because you are drawing steadily, but only add to the pose that you see at that moment. Gradually, each will acquire enough information to become a plausible sketch — unless the activity finishes before you do. If that happens, put the drawings away until another time.

When you are used to drawing slow movement, look for something faster. Joggers in a park or swimmers in a pool are examples of activities where the movements are fast but also repetitious, which will allow you to study your subject well. This gives you the chance to grasp the pattern of changes and set down notes that can either be built into a drawing on the spot, or be transposed into a more complete work later.

As your hand and eye coordination improves, you will find yourself watching the activity more than the drawing. It may be difficult to keep figures in proportion, and some of your results will look odd at first, but practice until you can record fast, one-off movements by keeping your eye on a moving figure. Children playing, a pony galloping, or figure skaters will be possible subjects now.

If you have enough time to depict more solidity, block the main tones in rapidly on your line drawing, softening fast with a rag or stump to create half-tones. (Pastel)

GREYHOUND

JOHN SKEAPING

Time spent watching rapidly moving subjects, and acquiring visual memories, is always well-spent. Tap into your research, combined with current observations, to produce dynamic studies. (Pastel)

Landscape: Pastel

PASTEL CAN BE used as a means of drawing, through linear marks and masses, as well as for its color qualities. This makes it an excellent medium for capturing the movement and energy to be found in the landscape. Working quickly, you can build up a range of gestural marks that suggest an ever-changing scene, rather than a momentary snapshot. By using colored paper, the exposed areas untouched by pastel will have a unifying effect on the composition.

Materials

Cream Mi-Teintes paper $\, \cdot \,$ Selection of soft and hard pastels (see page 68 for color list) $\, \cdot \,$ Stump or wiper $\, \cdot \,$ Kneaded eraser $\, \cdot \,$ Fixative

Thumbnail Sketch

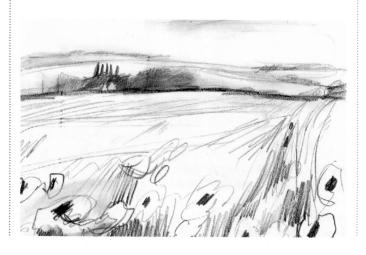

Apply foundation marks

Make a quick start by loosely applying the main blocks of color. Although placing the key masses of these colors is all that is needed at this stage, they lay the groundwork upon which the movement, tones, and color can be built as the drawing develops. A sense of depth and directional forces within the drawing has become apparent already, through the variety and sizes of marks made from the foreground to the background.

STAGE ONE
Position the
main color
masses with
loose strokes

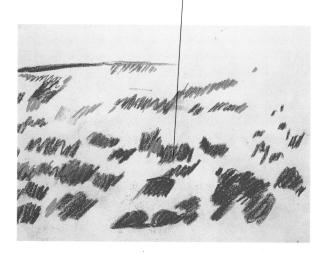

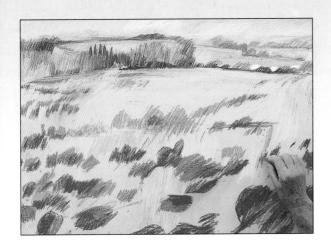

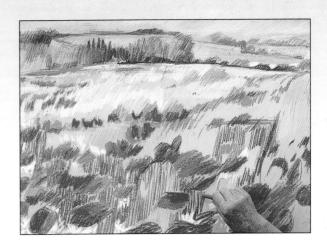

Introduce cooler colors

Keep these first marks fresh while establishing the main color areas, and pay close attention to the tonal ranges you introduce; committing yourself to dark tones can easily muddy the surface. Cooler, lighter-toned colors, that can be darkened later if necessary, recede toward the horizon, and warmer ones push forward. The sense of movement can be suggested by the freshness and direction of your marks.

STAGE TWO
Suggest depth
with the use
of warm and
cool colors

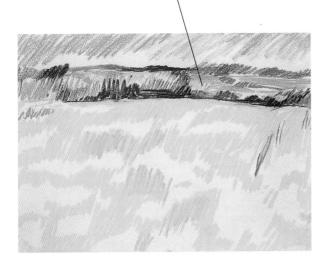

Emphasize areas of color

Using a stronger approach to colors at this stage puts into context those you have already applied. Working on a cream-colored paper means that when lighter tones are added, any exposed surface can then be used as a middle tone, making for a warming and unifying effect where it appears across the surface of the drawing. Simple directional lines, accurately portraying what you have observed, can add energy and vitality to your work.

STAGE THREE Strengthen colors and draw out the scene's movement.

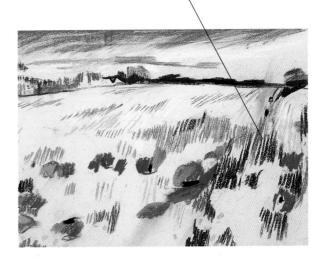

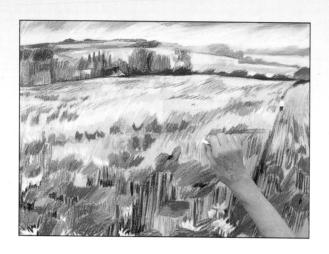

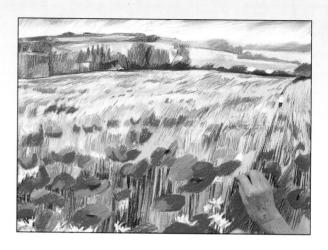

Develop quieter elements

Start to introduce details, still working in a loose and gestural way, and continue the process of emphasizing and contrasting the movement within the image. The gradations between the lively marks in the foreground and the quieter passages in the backdrop and sky are reconciled to give a credible sense of depth, rather than appearing to be a series of scenic backdrops. Introducing figures can help to give an anchor to the overall image.

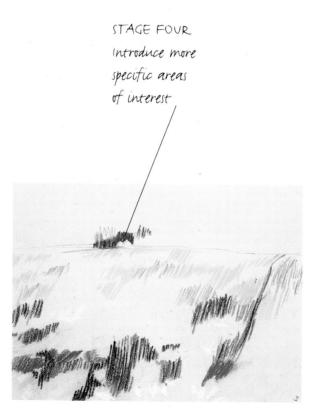

Strengthen color masses

Using your fingers, rub in the soft pastel to create more solid blocks of color where this may be needed. A paper with tooth is essential for pastels, but rubbing can also help by pushing back the texture of the paper where it is too obtrusive. Check frequently for areas that may need to be given a more prominent role within the composition—this can be done by lightening the tones that lie immediately around them.

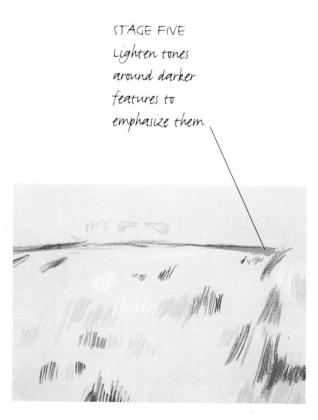

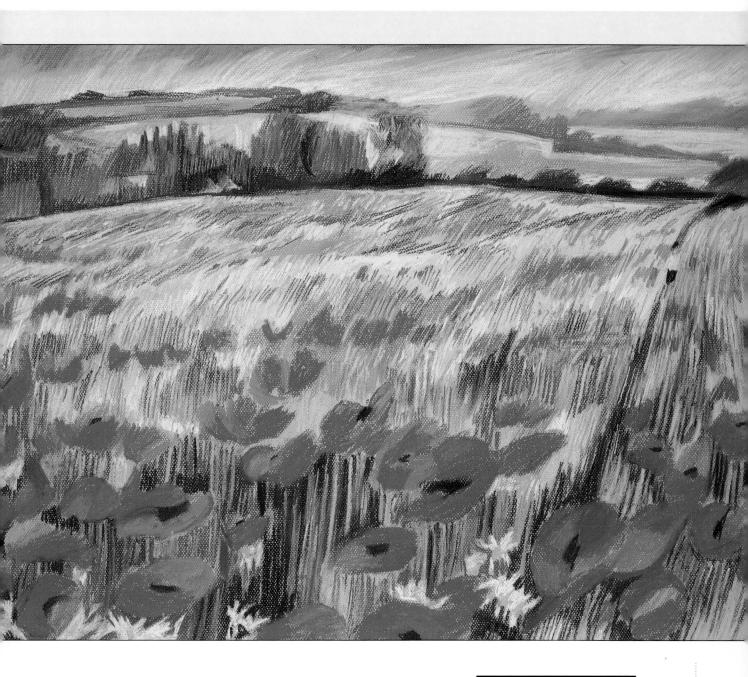

STAGE SIX
For definition,
define points
where colors
meet

FIELD WITH POPPIES

PIP CARPENTER

The final gestural details are added with hard pastels. Reinforce areas where colors meet, to give definition. Don't work as if the whole page should be covered with pastel—rather, use its tone to your advantage. Although the final work is full of gestures, color, and movement, rather than a precise botanical illustration, it should still be believable. The elements should not be floating in mid-air, or appear half-hearted, unless you particularly want them that way.

Figures: Pen and Wash

THE INCREASE IN confidence you experience as you train your visual memory, and improve your hand-and-eye coordination, should encourage you to try drawing some faster moving subjects. Keep any scraps or fragments you draw; they are valuable reminders of what you saw, and have the credibility of observed information. Because it does not require dipping, a technical pen is useful, and the ink is usually fixed when dry, so you can add ink or watercolor washes to record the broad color values. For speed, mix basic colors in a mixing tray before starting.

Materials

Hot-pressed watercolor paper, or smooth, acid-free drawing paper • 2B drawing pencil • Plastic eraser • Technical pen with 0.5mm nib • Selection of watercolors or colored inks (see page 68 for color list) • Mop brush • Detail brush • Mixing palette • Craft knife

Thumbnail Sketch

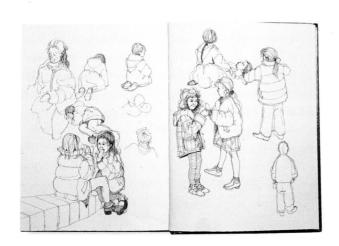

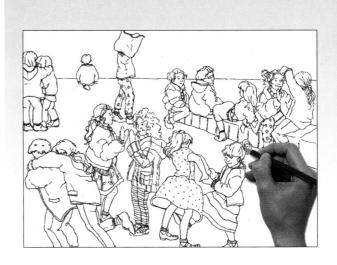

Transpose your sketches

When drawing from observation, work directly with your pen to capture action, and the freshness of the result will compensate for any inaccuracies. When transposing studies from a sketchbook to make a composite design, first make thumbnail sketches to decide on the composition. Keep your options open by working on larger paper than required, drawing in pencil first so you can erase to make corrections if you decide to move figures around.

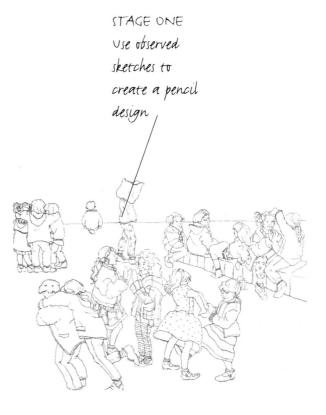

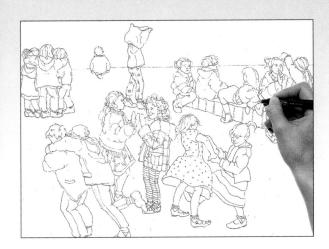

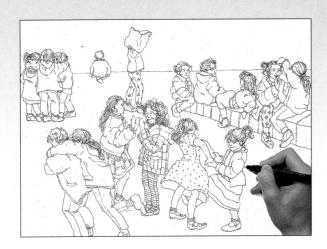

Draw the ink lines

Working in pencil on an oversize sheet also means you can extend your design if you have truncated figures in awkward places. Check your pencil sketch before you start pen work, because subsequent alterations are difficult. Take care to draw as freshly as possible over your pencil lines, because inking them in without using the chance to evaluate and redefine can produce stale work and lose the vivacity that is the charm of pen drawing.

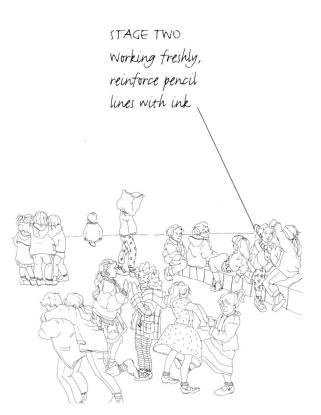

Draw tones and textures

Some of the work of describing form in the moving figures will be done by color washes, but you should complete any tones and textures you want to show in pen at this stage. Patterns and folds on garments, or the texture of hair, can be drawn into with the pen point, and left as line or augmented with a wash later. Be sure to refer to your sketches for this information; invented details will lack credibility by comparison.

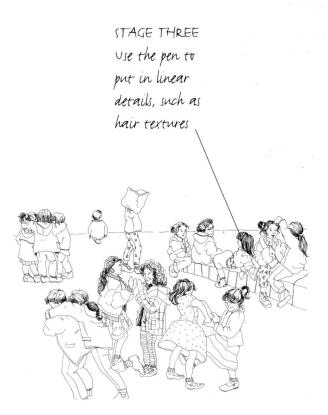

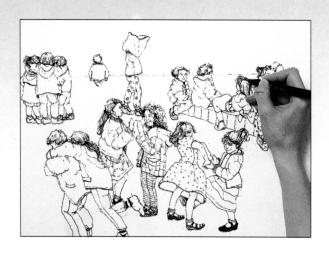

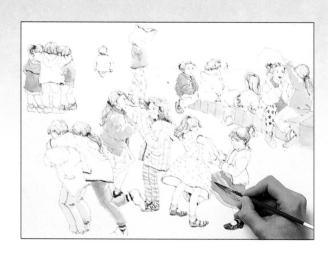

Apply broad washes

Lay down washes freshly: they will look better if cleanly handled. Remember to damp large areas in advance to spread them evenly. By working against the light, you will see the wet area clearly. Detail brushes are useful for painting wash into corners, but large brushes are easier for working across major areas. Because you are using color notes or memory, group broad washes so that you can balance warm colors before adding cool ones, or vice versa.

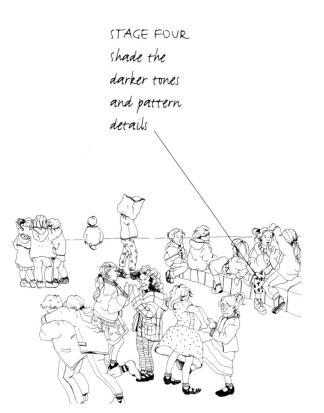

Introduce contrast

Add further washes to create a color balance, perhaps with a bias toward warm or cool; an equal division of color temperature looks less interesting than a majority of one enlivened by a smaller contrast of the other. Let washes dry completely before washing overlays of adapting colors over them. Drying edges will create darker bands where washes overlap, so damp them in advance if necessary, and make sure you mix plenty of wash so you can avoid delays.

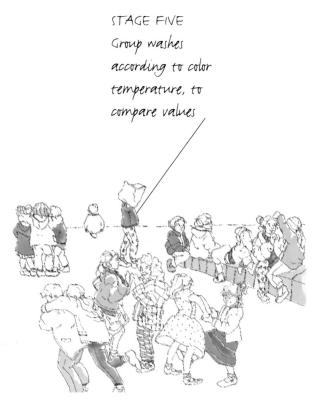

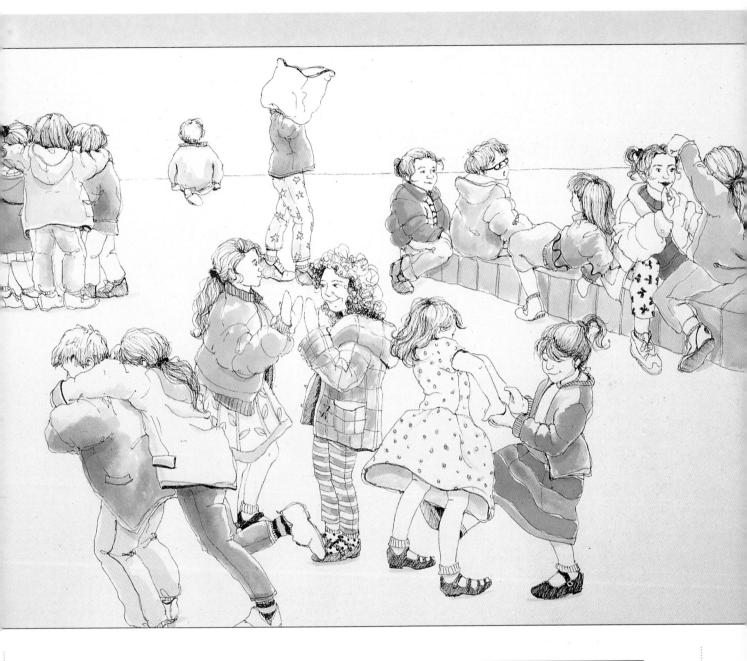

STAGE SIX
Balance the
color scheme,
and adapt
washes with
overlays of color

PLAYTIME

JULIE JOUBINAUX

Apply detail washes to represent smaller patterns and textures, or enrich tonal values to show form where line alone is not sufficiently descriptive. There is no need to wash everything, and your work will lose some of the liveliness of the line if you color in all the figures. Where your color notes are incomplete, or you have no memory of the shade or hue, the best solution is to leave the line alone to show form and movement.

Gallery

To represent movement with conviction, try to draw what you see or glimpse as faithfully as possible. Even if what you show is vague or ambiguous, it will be rooted in observation, and it will be closer to the appearance of motion than the static images of moments of time that result from working from photographs. For maximum speed use line drawing, making color notes in line that can be augmented when time allows.

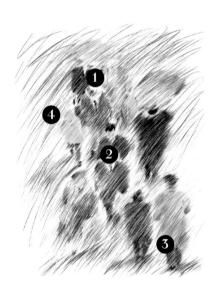

Attention points

A hurrying crowd, seen from an upper window flecked with driving rain, may seem little more than a blur of color at first, but perseverance will identify some tangible shapes to note down — an umbrella here, a raincoat there — until some plausible figures have emerged. Colored pencils are used here, and are ideal for occasions when your subject requires you to work quickly.

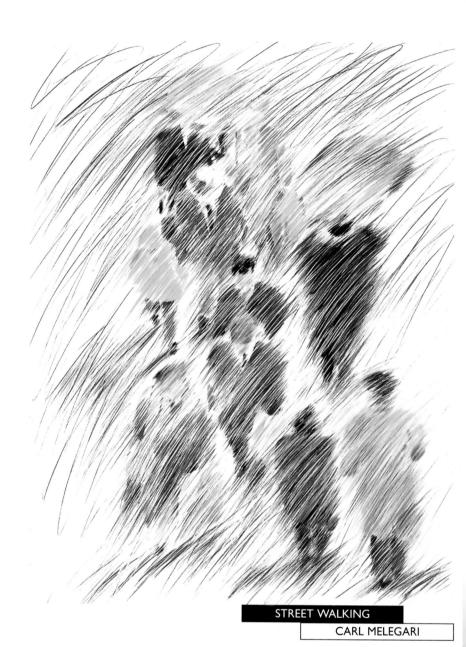

① Distant figures may not be seen complete, so use fragments high in the picture frame, concealing omissions with fuller studies drawn from slower walkers.

2 Observe similarities carefully, such as the angle of heads turned down against the driving rain. Keep this consistent in all bent heads, to endorse the impression.

3 A too-specific technique is not always ideal. Consider using broad hatching, vague in general, and define it when more information is available.

A Remember to organize the tone and color schemes to reinforce the impression of driving rain, using mainly cool hues.

Key Planning Points

- On location, watch how figures change the overall shape of the scene, and place additions so that you retain a balanced composition
- When making a composition from sketches, arrange them first, and try a thumbnail sketch before transposing them

Attention points

Drawing a pet or domesticated animal is a good way to study movement, because you will be familiar already with the characteristic forms and attitudes of the creature. Animals tend to remain still only when they are asleep, but they may rest or return frequently to a similar position, for example on a perch. Make several quick sketches to consolidate your knowledge of its appearance in the round. Choose a medium you are confident with, as you need to draw quickly; the artist has used pen and wash in this series of studies.

- 1 Begin by drawing body shapes, and ensure that you have shown the correct dimensions before beginning on surface details, such as the texture of feathers or colored markings.
- 2 Pay attention to the noticeable effects of perspective, such as a full-face view with foreshortened eyes.
- 3 Different breeds may show other types and textures of plumage, conveying different impressions of character. To help you capture this effectively, experiment with descriptive marks until you can effectively represent fluffy feathers, quills, or down, the hard glint on a beak, or the scaliness of bird legs.

- 4 When drawing features such as claws gripping a round perch, or plumage folded close against a curved body, pay attention to the appropriate curvature.
- 5 If it is in a lively mood, a bird may hop, shuffle, or squawk. Each movement is worth recording, however briefly. A sheet of such studies will contain enough information for a plausible, composite drawing, or will serve as a memento of a creature in motion.

Key Planning Points

- Organize your studies so that they are well-spaced on the sheet or page
- Plot the elements, such as patterned feathers, that change scale on a curved form, by mapping them in line first, to check for the correct size

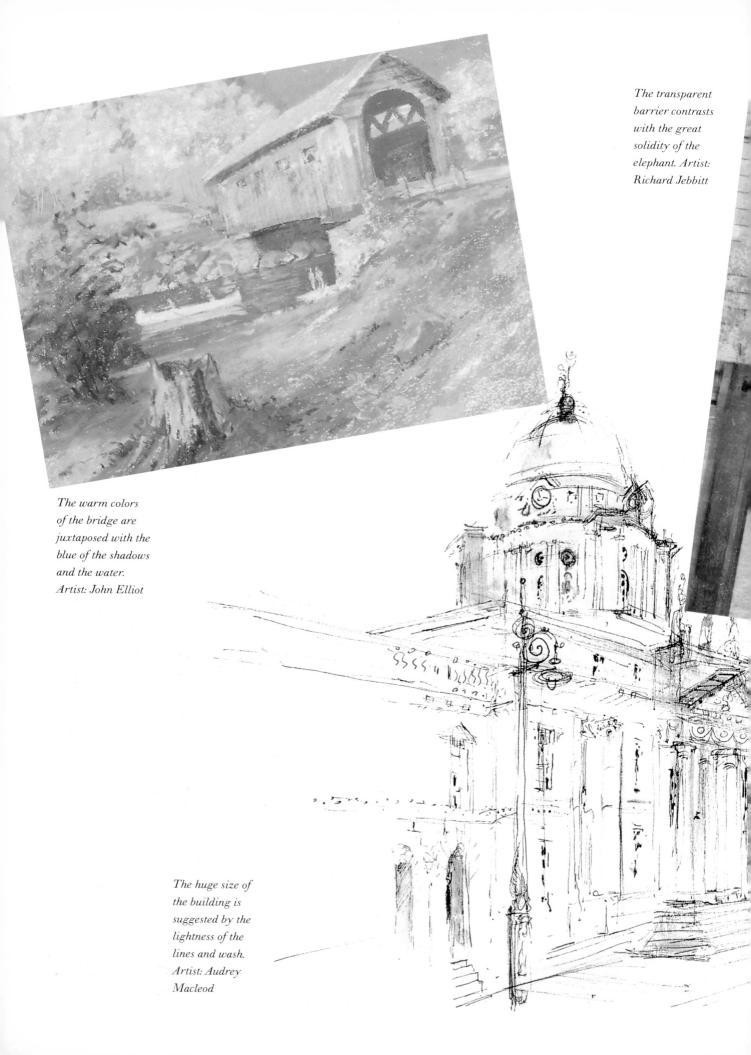

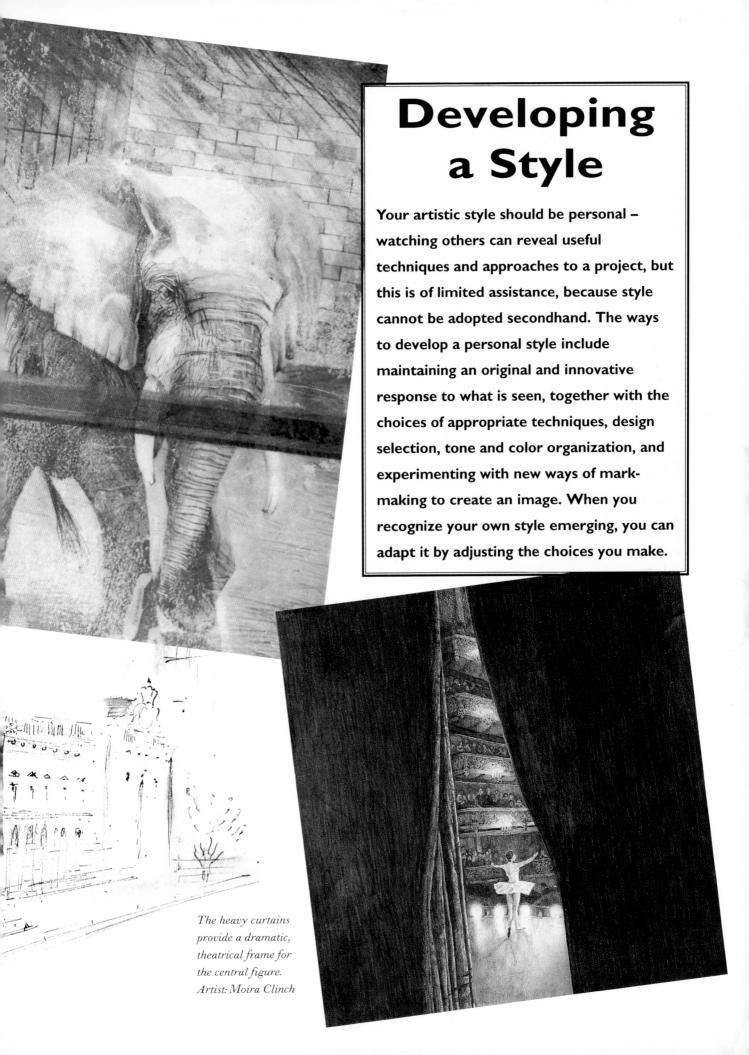

Introduction

By completing your own versions of the projects in

the last chapter, you have gained a knowledge and understanding of good drawing practice, reinforced by your own discoveries and experiences. Now is the time to use the skills that you have developed in work that is original to you.

there is no need to seek out the extraordinary or bizarre as a way of creating something new, although in the course of your progress, you may come across a vision so compelling that you want to interpret or record it. Until you are sure of your preferences, turn to the evergreen subjects that preoccupy artists — still life, landscape or townscape, and portraiture. These are reinterpreted by each new generation because they are full of interest, within easy reach, and lend themselves to an individual approach.

IOUN LIDZE

JOHN LIDZEY

the new factor is you, with all your characteristics, aptitudes, and persuasions. You are the person who makes the drawing, so reflect your unique combination of qualities with an interpretation based on your personal choices. Indeed, one of the attractions of drawing is that your results are determined by your own preferences. Let others influence your work, but as

an inspiration, not a stylistic restraint.

The subjects may be standards, but

SUSAN WILSON

The drawings on this page demonstrate the wealth of opportunities available to the artist from everyday scenes. In John Lidzey's still life, the contrast between the busy marks of hatching, smudging, and scribbling, and the area of white paper that represents the pool of light, creates a tension. Susan Wilson also leaves parts of her paper untouched, but to suggest a gentle fall of light onto a rounded baby cheek.

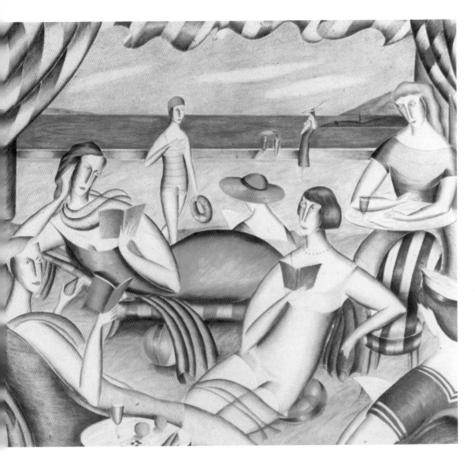

SEASIDE

CATHERINE DENVIR

These two interpretations of groups of figures have much in common with each other, even though each is immediately recognizable as the work of a particular artist. In Sally Strand's naturalistic drawing, the colors and patterns are repeated in the blues and yellows of the shadows. Catherine Denvir's highly stylized drawing also uses repetition in the blues and yellows, and in the vertical lines and billows of the awning and clothing.

SALLY STRAND

There is no need to strive for self-expression as you work; your artistic identity will emerge, almost of its own volition, perhaps to surprise you, as you concentrate on the tasks in hand. Be brave enough to follow your intuition if you feel impelled to draw in a certain way. The impulse will be based on your personal reactions to the subject matter, combined with your experience of the expressive qualities of drawing media, that will prompt your interpretation.

Following this prompting will result in progress, because your instincts are your best guide to developing your own unique, personal style. The drawing that results may not be a complete success, but contained within it will be the harbingers of future work, and technical innovations to build on for a new approach.

It is through such efforts that skills are increased and new ground is broken. Your discoveries will be original, whatever your stylistic approach, and will enable those who look at your

drawings to see the subject through your eyes. This is an ability to communicate of an instant and powerful kind, so use it wisely, and consider the nature of the images you create.

Still Life

TO ELICIT A personal response, consider your involvement with the objects that comprise your group. A good start would be the things on your own kitchen table, because it is closely associated with your daily life, even if you make nothing but coffee at home! The more bound up you are with the objects, the better you will draw them, because by looking at them with real interest, you will observe them well.

Add to the impact of your work by selecting a group that has a recognizable theme. This can be based on anything: natural forms, the geographical or ethnic origins of the items, a philosophical idea, or a single factor such as the color of the objects. A few items and a simple set-up should be sufficient.

Make sure that your objects and their setting are chosen for their varied visual qualities – try glossy and rough, transparent and opaque, or round and angular. Look at the overall shape of the group, and judge when to balance low things with a tall one, or to place tiny items on a unifying background.

Materials - Kitchen Table (top row)

Hot- or cold-pressed (not) watercolor paper, or acid-free drawing paper Graphite stick or pencil in grade F, 2B, or 3B • Plastic eraser • Fixative

Materials - Home Cooking (bottom row)

Hot- or cold-pressed (not) watercolor paper, or acid-free drawing paper • Selection of aquarelle pencils (see page 68 for color list) • Plastic eraser • Mop brush • Detail brush • Small sponge • Gummed paper tape

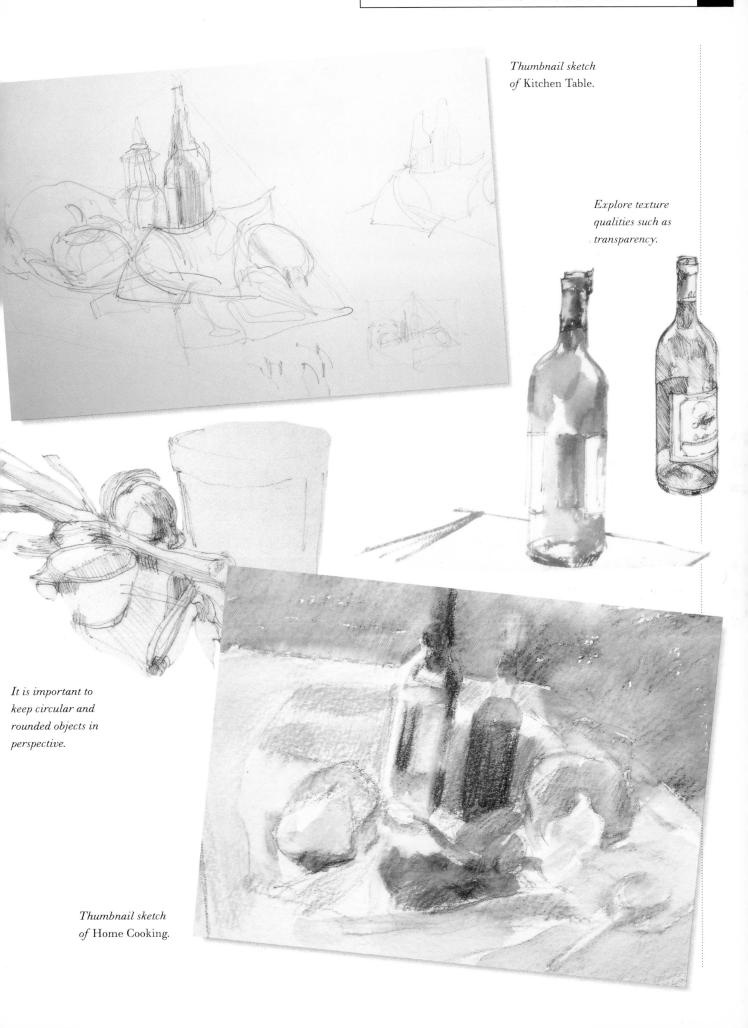

Making a monotone drawing

This view has the overall shape of a triangle, resting in a broad base — a stable but weighty framework that, without the space created by color, needs to be livened up. By making an interesting arrangement of the folds in the table covering, you will create more dynamic movements through the three-dimensional design. The cloth links the objects with curvilinear shapes, providing a good contrast to the dominant, straight forms of the bottles. Draw the lines and tones of the basic composition freely with a graphite stick, and evaluate and adjust them rapidly.

Monitor the perspective

Circular items cannot have sharp corners, so examine any ovoid shapes, such as the surface of the liquid in the bottles, and ensure that the extremes of the ellipses are tightly curved turns, not angular, pointed junctions. Draw regularly shaped objects, such as the bottles, by working across them and recording the evidence of solidity, including the tonal information. By developing them as three-dimensional forms, you will be able to keep them symmetrical. When the overall structure is established, reinforce the darker tones with the graphite stick.

Drawing for washes

Using aquarelle pencils takes judgment in gauging the amount of pigment to lay down to achieve a color wash, and in deciding how much water you need to wash over it to create the required intensity. Until you gain experience in diffusing color, build up to full strength in stages. You can erase the current work at any stage when drawing on dry paper, but not color washes that have been allowed to dry. Shade the main areas lightly, and wash over them with a mop brush to create a pale base for later work.

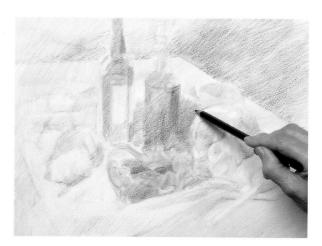

Adjust the dimensions

The drawing is now being made on paper tinted with lighter versions of the final colors, but there is plenty of room for adjustments. Use the base as a platform from which to reach a more accurately drawn representation. Check dimensions and perspective now, because strong, dark, background colors are immovable when washed over, and errors will be set. If disasters occur, apply white gouache or even paste on clean paper, but only in an emergency. Correct at this stage with an eraser.

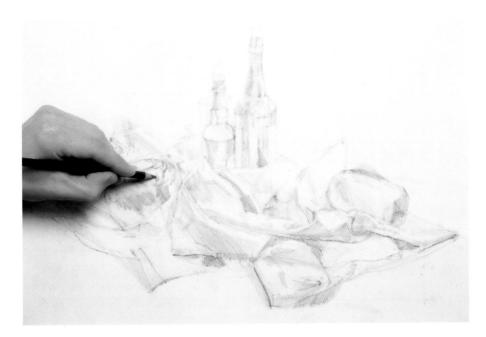

In this
drawing, the
dynamic
and
decorative
pencil
techniques
are well
suited to the
organic
vegetable
forms

Define the objects

To sharpen the definition, use a pencil of the same grade as the graphite stick, or close to it. Wide differences in grades allow the softer and blacker to dominate, effacing those which are harder and more silver-hued. As you define your objects and their surroundings, make use of the opportunity to develop the subtleties of the three-dimensional design. Decide by observation which of the linear movements through the two-dimensional plan to emphasize, and which tonal contrasts to increase almost imperceptibly, to organize the visual progression around the group.

Here, the painterly use of aquarelle pencils has echoes of a rich watercolor treatment

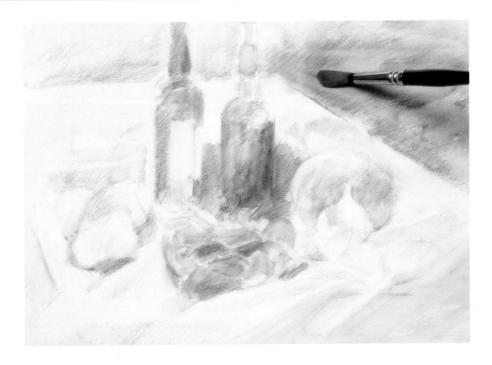

Refine the drawing

Washing in the heavier pigmentation laid down will create stronger color mixtures. Load your brush with clean water, and rinse it between washes, to avoid polluting colors. Refine the drawing as you spread each ensuing wash, evaluate the comparative wash strengths as you work, and quickly remove any that appear over-strong. Use a detail brush to spread wash into small corners, and blend in by washing out the edge with a brush or sponge.

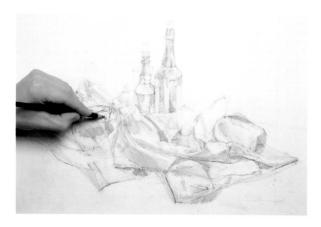

Resolve the solidity

The aim now is to resolve the solidity of each element. Much of the information that makes the items palpable is tonal; develop the tone evenly, so that you can compare the relative strengths. Avoid working on fragments or isolated "islands" of tone — these are unconsciously compared to the remaining white paper, instead of the adjacent values. Enrich the tonal scheme steadily by even development; stand back frequently to assess the relationships throughout, and determine the depth of tone required by half closing your eyes and peering through your eyelashes.

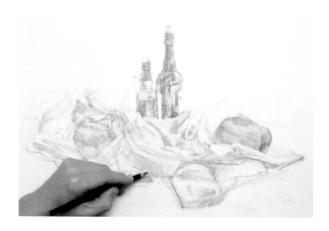

Consider the surface textures

When the forms appear to be tangible and to possess weight and density, consider the details of their surface appearances, because these depend on the different substances of their composition. Differentiate between the glossy shine and polarized tonal contrasts of glass, and the delicate sheen on the raised folds of the cloth. The vegetables reflect light in yet another way, from the pearly nature of garlic bulbs to the polished shine of dried chilies. Devise the subtle marks that will render these different qualities appropriately by direct observation.

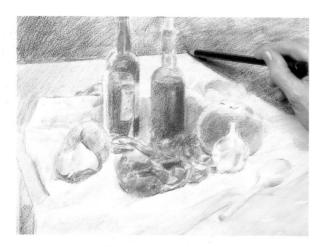

Adjust the color mixtures

Correct the colors where there is a mismatch, and reinforce those that are are under-strength. Clarify the structure by refining the definition, sharpening the tonal contrasts, and drawing the specific shapes. To counteract a bright hue, use a thin glaze of the exact opposite — for example, yellow dulls purple. If broken cover captures an effect better, try scrubbing or scumbling over light shading. When satisfied with the trial effects, shade the drawing appropriately to repeat them as required.

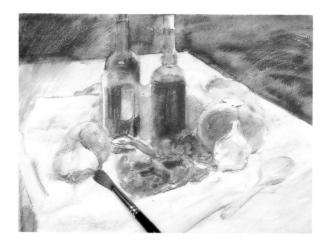

Reinforce the washes

There is now a considerable amount of pigment on the paper surface, and depending on the brand of aquarelles, this will behave differently when washed. The harder type is reasonably stable, if lacking strength when wet, but the softer-consistency pencils tend to move when wet. Pigment is difficult to control when it is sliding around in a wash, and overworking soon loses freshness; avoid problems by keeping soft pencil washes less wet, unless you are prepared to accept loose results.

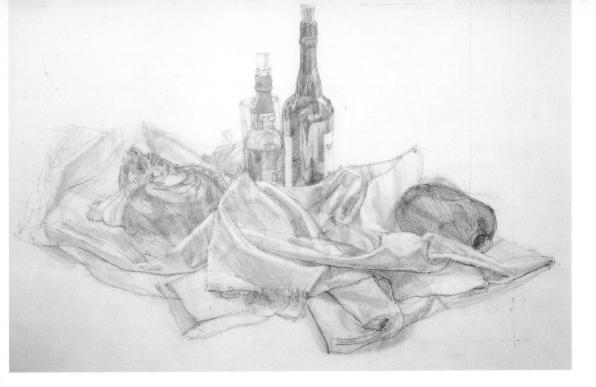

KITCHEN TABLE

JODY RAYNES

Make sure that you have drawn sufficient tone and textural detail to provide adequate descriptions of the subtlest changes of contour on the objects, and the appearance of their distinctive qualities, such as transparency. Glass warrants particular attention. Look carefully to determine whether you have allocated the correct value to the portion of the bottle you are evaluating. Check the strongly graded tones that show the circular form, the muted values of the area beyond, glimpsed

through the glass, and the opaque brilliance of the highlights that resist the penetration of your gaze. If you have misplaced or misrepresented any of these, the bottle will have a faceted or chunky appearance, or look flat and implausible. When satisfied, fix the drawing lightly.

HOME COOKING

VALERIE WIFFEN

To retain the identity of the work as a drawing, complete the finishing stage in dry aquarelles. It might be classified as a painting if it is washed over again, making the brushed pigment cover virtually solid, but the boundary between drawing and painting is an open frontier. Even now, errors in pencil can be removed with an eraser, but it will have no effect on areas where brighter values have been accidentally dimmed with a wash. White gouache lightens color tonally, and brilliant highlights can be restored by scratching them out carefully with a sharp knife at the end.

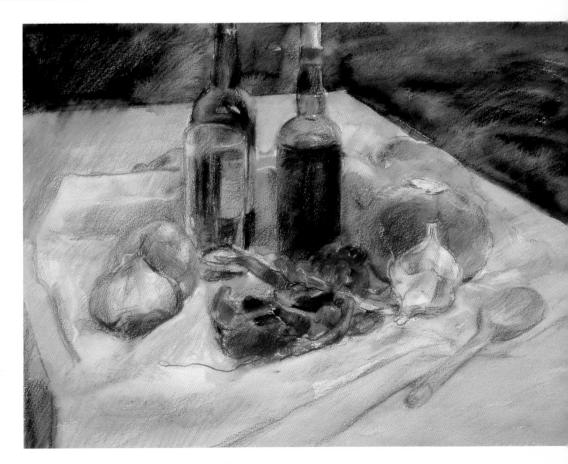

Townscape

THE WEATHER IS a major factor in influencing the quality of the light in outdoor drawings. The seasons affect light levels, and the direction of the light changes with the time of day. You may experience difficulty in finishing at one session if the sun moves, or if there is a downpour. If transient effects are not captured at your first session, accept that tenacity may be required to finish the drawing. Return when there is a repeat of the same weather conditions or time of day, or even leave the work until the same season next year. Catching the right conditions again is easier if you work close to where you live, and a familiar view is the perfect subject for a personal interpretation.

Because ignoring anything within your format is difficult and obliges you to invent what you would have seen instead, simply draw everything you see. Make sure that you choose a vantage point that gives a view you are happy with. If necessary, adjust your position or eye level until the aspect you dislike is not visible, but if vehicles are in view, remember that they are part of contemporary life, and by avoiding them, you may produce an oddly deserted scene.

Materials - Autumn Sun (top row)

Hot- or cold-pressed (not) watercolor paper, or acid-free drawing paper

• Selection of colored pencils (see page 68 for color list) • Plastic eraser

Materials - Montague Road (bottom row)

Hot- or cold-pressed (not) watercolor paper, or acid-free drawing paper

• Medium-grade charcoal stick and pencil • Stump or wiper •

Kneaded eraser • Fixative

Establish the colors

A steady process of accumulation of ever-finer detail is always a reliable way to approach a busy townscape scene. Make sure that you establish the spatial relationships early on in your drawing, because no

matter how convincingly you draw later details, the result will be disappointing if the scene is not a plausible image of three-dimensional form in space. As you block in the main colors lightly, follow the perspective of the street, and check that horizontal planes below your viewpoint appear to slope up as they recede away from you, while those above seem to slope down.

Create color mixtures

Blend color mixtures by superimposing shading in selected hues over each other, to match the observed values. In media where colors are mixed as you draw on the paper, such as the colored pencils used in

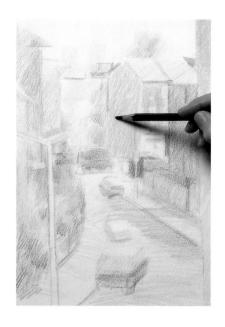

this demonstration, a blend that is too light or dark may cause problems, so proceed carefully. Provided you have duplicated the tonal value of the required colors accurately, an altered degree of warmth or coolness will not disturb the perception of the forms. Build your mixtures up to strength gradually — the color will not fill the paper tooth until pressed firmly.

Start in monotone

A sparkling view of sunlight and shadow is a suitable subject for a strong monotone drawing. Charcoal stick marks can be erased completely with an eraser, but applying material that

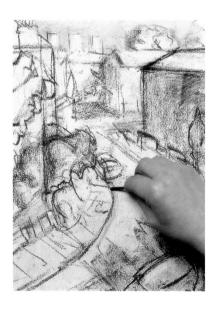

you are obliged to remove later when you see your errors is no fun, so make a loose, open start, with room for amendments. Changes are easier to make if you keep your existing marks to guide you while you mark out a new position, erasing them afterwards. This way, each unsatisfactory mark acts as a springboard to a better statement. If your revised drawing still looks out of perspective, readjust and evaluate until you are satisfied.

Block in broadly

Once you are sure that your layout is in perspective and in proportion, enrich the lightly indicated tones by blocking in the main areas of shadow. Keep the values broad, as nothing will be

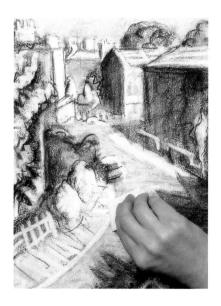

gained by diversifying into detail too early, and you need to realize the three-dimensional nature of the view, a task best accomplished with freely handled, simple blocks of tone. Include any movable elements, such as vehicles, in your view. Incorporate every feature into your considered two- and three-dimensional design; the perception of the whole, and the spatial relationships within it, are essential to see from the start, without having to tag extras on later.

Introduce contrasts

Capitalize on the arbitrary factors of flowers, painted items, colored garments, or advertisements, because these will provide you with a useful foil for the quieter natural shades of wood, stone, or brick. Remember that you will need to soften even the most brilliant colors if they are distant, but in the foreground, give the brightest colors full strength to increase the illusion of proximity. For recession, use the spatial properties of color: in general, blue is recessive, yellow stays on the picture plane, and red comes forward, so introduce red clothing when you can in the foreground, but keep distant values cool. If you dim mixtures accidentally, try removing the unwanted color with an eraser.

The restrained color in the fine detail of this drawing creates a delicate rendition of pale spring sunshine

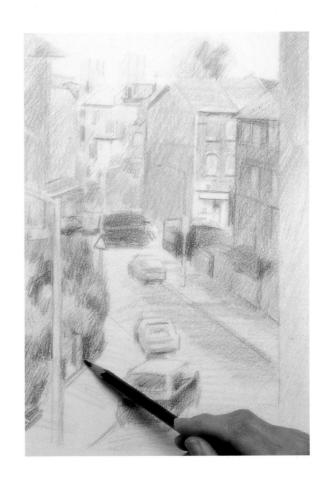

Consider the weather

This stage captures the effects of weather. Transient effects may prompt rapid recording, but the sunlight is the main focus of the work, giving the view a particular identity. Such an integral aspect should have your full attention, and exert an influence on the way you represent everything on view. When you have selected a project for a particular visual quality, maintain a heightened awareness of it, so that you look for evidence of it first, not as an afterthought. Draw the highly contrasted tonal scheme in bright sun that provides you with a handy simplification, because the dazzling light conceals many of the subtler small tonal changes. Begin to sharpen the definition with the thinner, worn edges of a charcoal stick.

The strong charcoal work here creates a vigorous interpretation that is in keeping with a busy urban setting

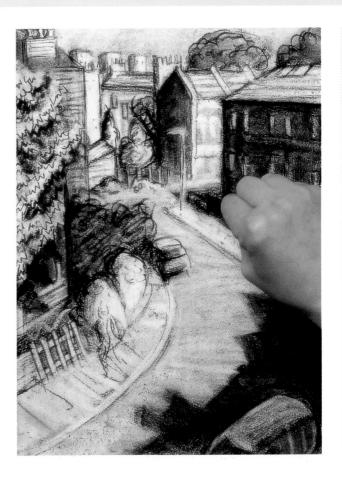

Increase the definition

The stage is set for decorative elements to be drawn with more precision: architectural features, automobiles, trucks, and variations in foliage. Intensify the clarity where you want to

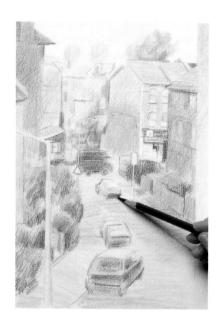

focus most attention — busy details always attract interest. If an area of heavy texture, color variation, or ornamental form is close to the edge of your picture frame, consider effacing or suppressing it. A less noticeable treatment will be appropriate, while a literal interpretation will take the viewer to the border or beyond. Draw foreground details and textures fully, especially at the center of interest.

Adjusting the values

The drawing is now complete, but in a rudimentary state that should be assessed at this stage. Evaluate it carefully, and adjust both the tone and color values. Where you may have contrasted, enriched, or

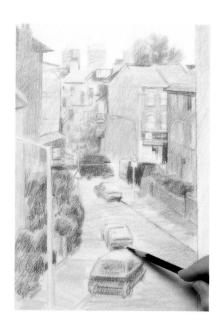

differentiated too much, soften and reduce the impact, then seek out the converse values, where you have understated or muted others, and strengthen them. This process of management requires discrimination, but decisions about what to relegate and what to foster are not difficult if you make them on the basis of evaluations from a slight distance.

Refine the tones

The initial broad blocking covered areas where lighter values and details are now required. Determine their positions, and pick out lighter details with an eraser. This has an oily content and responds to

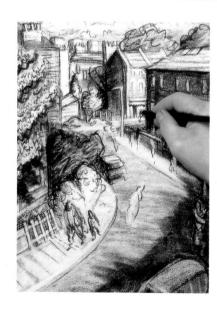

the warmth of your hand; it is kneadable into a specific point to pick out fine lines, such as street lights. At the same time, refine the darker details, using a charcoal pencil if you need a point for linear elements such as tiles or brick. Include walkers if you want to create the impression of a thoroughfare. If you cannot finish a figure detail from one person, take it from a similar passer-by; it may be a composite, but one based on solid observation.

Draw the texture

While you have been observing the effects of sunlight on the tonal scheme, resolving the solidity of the architecture, and capturing passers-by, the patterns and textures may have been shelved. Revise

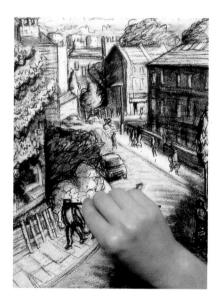

the drawing, examining the surface textures, such as concrete or brick, the glitter of glass and metal on parked automobiles, the tree or plant textures, and the clothing of the walkers. There is scope for the decorative use of architectural details and repeating patterns of balconies, chimneys, and fences. These are secondary sources of interest, and require less emphasis than the tonal aspects that are the main elements of the drawing.

AUTUMN SUN

VALERIE WIFFEN

Sharpen your pencils well, because this kind of interpretation relies on a wealth of accumulated detail for interest, much of which is fine and small-scale. Now that the drawing has credibility, it is safe to begin to introduce all the tiny details of window panes, glazing bars, road signs, and other minutiae, without the wasted effort of misplacing them. Many of these will add to the decorative content of your drawing, and in rows and terraces where the features are aligned, they will contribute an element of repeating pattern. If you enjoy the process of drawing finely, continue adding tiny elements until you have built a patchwork of fascinating detail. If your capacity for working small-scale is limited, stop sooner, because this is entirely optional.

MONTAGUE ROAD

TONY COOMBS

The basic design has been firmly under control from the start, but enough transient factors have been introduced in the course of drawing to require an overall revision of priorities. Check the tonal scheme, and verify that you have sufficient depth contrasted with brilliance to convey the sunlit effect, and no overbright tones within cast shadows, or rich, dark hues within the brightly lit areas. Evaluate the half-tones, adding any that you see to be necessary, particularly where these describe a texture such as the road. Examine the shapes you have given to trees and foliage, and draw into them in more detail with a charcoal pencil if they seem oversimplified. Then add the final figure details, and spray lightly with fixative.

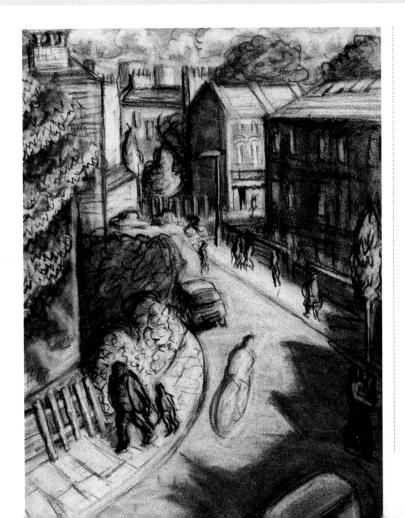

Portrait

FOR PORTRAIT SITTINGS, remember to time the session. Professional sitters need a break every hour, but others need to rest more often. An older person may be willing to sit over longer periods, but will need to move frequently to avoid discomfort. Small children are never at rest for long unless absorbed in an activity. Draw

them on several occasions, then use the sketches and fragments to build a composite drawing. You will have scope for a personal interpretation based on your observation, while using the sketches to jog your visual memory.

The perfect portrait subject is an adult who will sit still for a moderate time on more than one occasion. This will give you the opportunity to evaluate with a fresh eye and achieve a better likeness. You will express more of the personality of your sitter through your observations than the photographic likeness produced with a camera, but be aware that your sitter is likely to be distressed by an outlandish representation – portrait drawing calls for a rendition that respects the dignity of your subject.

Materials - Architect's Grandchild (top row)

Hot-pressed watercolor paper, or smooth acid-free drawing paper • Reed or bamboo pen, or dip pen with drawing nib • Brown ink

Materials - Blue and Gold (bottom row)

Cold-pressed (not) watercolor paper, stretched and tinted with neutral wash, or acid-free, neutral-colored pastel paper • Selection of soft pencils and pastel pencils (see page 68 for color list) • Stump or wiper • Kneaded eraser • Fixative • Gummed paper tape

Drawing selfportraits helps to practice capturing expressions.

The shading and hatching of the head are contrasted by the simple collar.

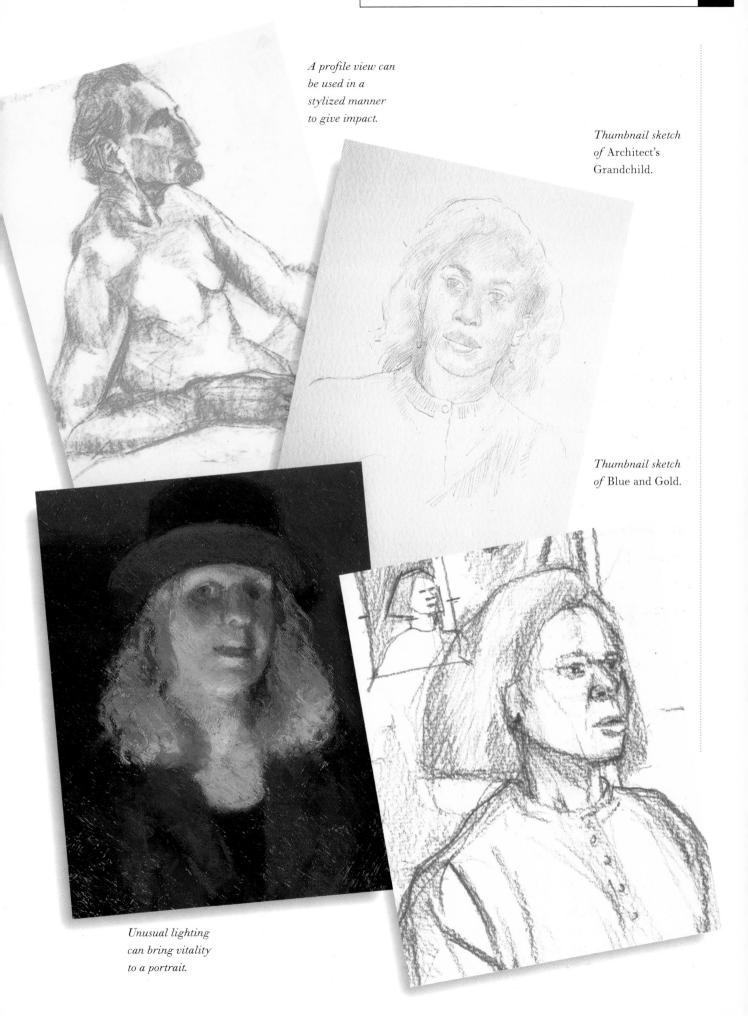

Deciding on monotone

For an accurate likeness, consider an approach where your image is created from an accumulation of fine marks. Colored ink gives a softer interpretation than black, and a reed or bamboo pen

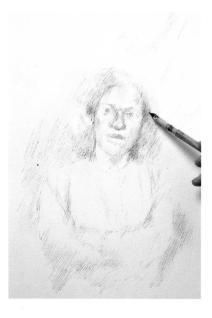

offers a range of flexible marks. Start by hatching groups of fine lines to represent the strongest areas of tone and cast shadows. When you have shaded across the strongest tones faintly, stand back and evaluate; if the proportions do not resemble your sitter, nudge the dimensions around with extra lines until you have fixed the elements in the right relationships.

Define the forms

Pen and ink
is forgiving
of minor
inaccuracies,
and you can do
a certain
amount of
adjusting, but
eventually
overlapping
errors will
become
noticeable.
Keep highlights
clear of ink by

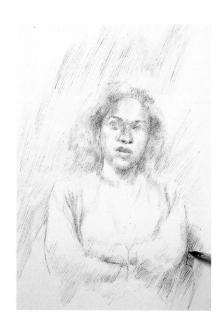

defining the boundaries of the main forms, gradually accumulating tonal density with fine lines. As you build up the depth of tone, stand back frequently to assess dimensions and proportions. You can change these in the early stages, but once the boundaries are set with stronger tones, adjustment becomes more difficult, because you will have dark values in places where you want light ones.

Define the priorities

A good likeness is not the only valid focus for a portrait. For colorists, and those who prefer rapid results, a fast drawing in soft pastel, with the emphasis on vibrant color, is an interesting

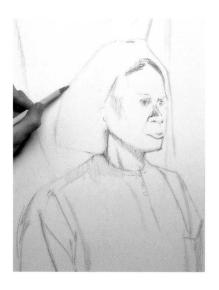

interpretation to tackle. Make sure that your sitter is dressed in glowing colors, and adjust the background to supplement the brightness. When you have more experience, adding mixed patterns to create a patchwork of carnival colors is fun, but keep to two or three solid colors to begin with. The first task is to delineate the basic composition with pastel pencils or the edge of your pastel sticks, keeping to line as much as you can, to avoid loading the surface with pastel dust in the wrong places.

Draw the rich colors

Establish coherent areas of the main colors and check that the relationships between them correspond to the values you see. Put in the richest and darkest values first – the paler

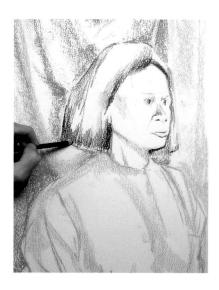

colours in soft pastels contain white pigment; once the paper surface has been drawn on with them, obtaining rich, strong values becomes difficult and means removing the pale pigment, because the white content blends with later additions. Similar problems occur when attempting to cover misplaced dark tones with light values, but starting to block in the rich, strong colors with the side of your pastels will enable you to consider the form by drawing the cast shadows. Apply the deepest colors cautiously.

Sharpen the definition

Continue to strengthen the darkest tones, and in areas where you are certain that strong darks are required — heavy cast shadows, or hair, for example — aim to reach a rich depth of tone, so that you can begin to establish the full range of your tonal scheme. As you confirm the accuracy of the position of features, you can locate them more precisely by sharpening the definition with stronger tone. Take care when placing darker accents and drawn details such as nostrils and eyebrows, even faintly. These will act as landmarks while you establish the subtler tones that reveal contour throughout the features, and even minor errors in perspective and position will make these into false clues as you continue to develop the drawing.

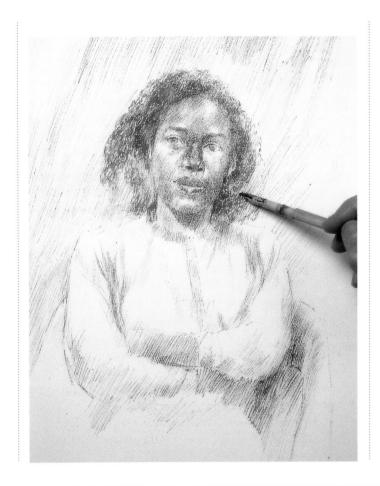

Draw the intermediate values

The delicate form can be defined with the fine strokes of pastel pencils, or the narrow edge of sticks. Aim for even development as you reinforce the dark values, and extend the tone and color scheme to include medium tones and lighter colors. Pastels lose their clarity when overworked, so ration the amount of reworking you attempt before removing surplus dust with a brush or rag wiper, then cleaning the remainder off with an eraser for a fresh start. Keep your hand high to avoid smudging, or lean on a mahlstick if your support is vertical. Fixing between applications is an option that is best avoided; the shiny deposit polishes the tips of your pastels and dims the brilliance of your effects.

The broad use of glowing pastels in a colorist interpretation makes for a strong, dramatic portrait

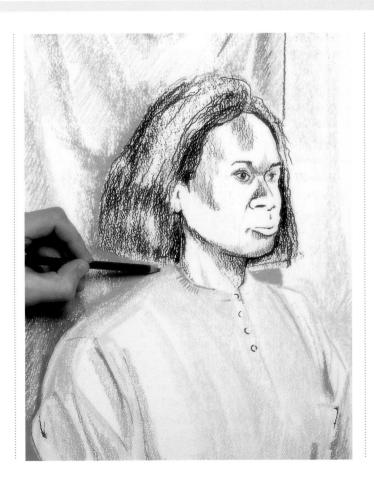

Fix the features

Develop the full tonal range, including all the nuances across the features. Rely on careful observation to deal with the complexities, especially if your sitter is illuminated by two different light sources. Directional

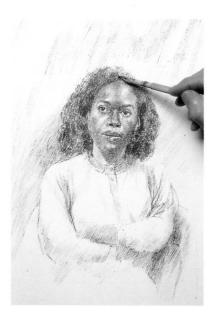

lighting from two directions may not be of equal intensity, so determine if one source is the strongest, and look for greater contrast on the affected areas. Reinforce the strong dark tones throughout, making them solid where necessary, and draw the darkest details of the features, that can now be placed with accuracy. Leave a tiny reservation of clean paper to represent highlights in the eyes.

Vary the handling

Hair and skin will have taken up much of your attention so far, but make sure that you have drawn enough detail on the garments. Folds and creases, on these and any background drapery, need to be observed

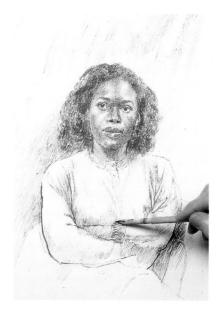

carefully, to gather authentic details of tone and texture. Because much of the handling on the portrait head has been fine and delicate, take the opportunity to deal with the other areas as freely as possible, to provide a visual contrast with a more bravura handling. Remember that if your initial statement is made in a fine line, corrections can be superimposed with a heavier stroke.

Simplify the tones

Quickly block in the remaining areas of color. Broad areas can be covered fast with the wide tip of pastel sticks, while finer work is easiest with pastel pencils, or a stick worn narrow.

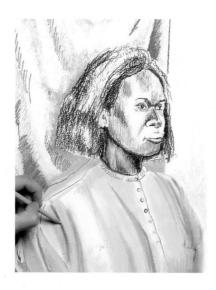

Simplification is the aim here, but remember that if you omit too much of the subtle tonal information, you will produce a rough-hewn effect. To create a simple, primary color scheme with an impact, screen out the smaller variations of hue, and the quieter values of shades that are lost in cast shadow. This treatment changes the perception of form and, with it, the impression of the sitter's personality. A rudimentary approach and brief handling convey a direct, energetic, and lively identity.

Make final corrections

One way to discover what you must draw is to include everything, then see which marks made things work. Another, as here, is to simplify the original material, then

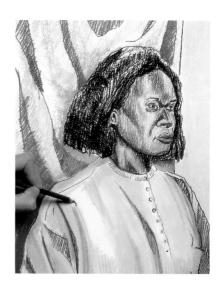

determine what essential information has been omitted and must now be introduced, if your drawing is to function as a plausible image. Evaluate the portrait carefully from a distance, and identify the elements, features, and values that should be completed to create an illusion of three-dimensional form in space. An omission may be the culprit, or an error in dimension may need to be adjusted. Corrections can still be made, but clean off surplus dust first, and draw firmly when you reinstate the form.

ARCHITECT'S GRANDCHILD

VALERIE WIFFEN

When you have adopted a method that slowly intensifies an image over a sustained period, expect to revise it thoroughly in the final stages, in order to unify the overall effect. Look for small drawing errors, omissions, and discrepant tonal values. Strengthening pale values should be done cautiously—it is easy to overemphasize at a late stage, when vigorous elements are in place and the drawing looks robust. Lightening the areas that are too dark is difficult, and you should confine your adjustments to those areas—lost highlights, for example—that can be scratched out carefully with a sharp blade, unless you are prepared to accept the inevitable loss of freshness occasioned by using white gouache, or the obvious presence of a patch.

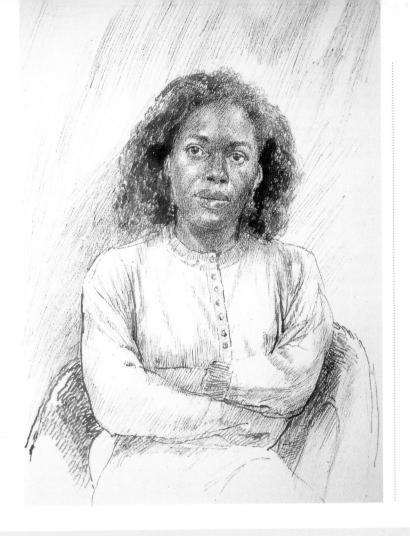

BLUE AND GOLD

RICHARD KIRK

The drawing must be thoroughly looked at for revision, because while you have been completing the final values, some accidental stresses or changes in tone or color strength may have distorted the planned design. Look for factors that have unified unexpectedly – in this case, the folds of the clothing and the background pull together visually, taking the eye in a diagonal direction across the picture. If you like the effect, enhance it, or reduce it if it is an unnecessary distraction. Complete the details of the features, and adjust any unmatched values. Pay particular attention to the relationship between the figure and the background, and reduce the contrast on the background if it does not recede enough. Apply fixative lightly, otherwise the brilliance of the colors will be dulled.

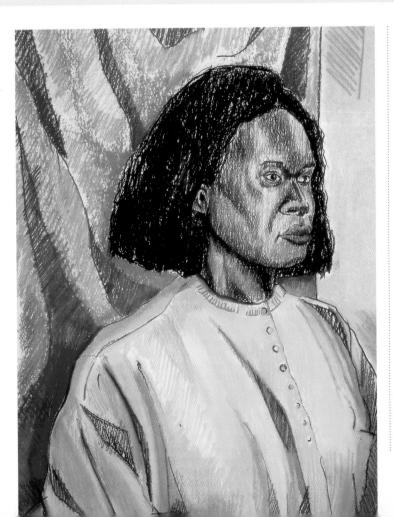

Index

Freda 57

Page numbers in italics refer	color 68 – 9	erasers:
to artists' drawings	demos $70-3$, $74-7$	kneaded 14
	gallery 78–9	plastic 16–17
A	lightening 69	
Adams, Sarah: Gravyboats 57	mixing 68–9	F
aquarelle pencils 24–5	overlaying 68	Fellows, Ian <i>30</i> , <i>31</i>
still life (demo) 70–3	spatial properties 118	Camellia 37
architectural settings 42	temperature 74	demo 34–7
in carré (demo) 46–9	Coombs, Tony	Kraków 49
in charcoal (demo) 38–41	Mike Reading 6	demo 46–9
asymmetry 42	Montague Road 119	Pumpkin 73
atmospheric perspective 57	demo 114–19	demo 70–3
	crosshatching 18, 68	figures: in pen and wash (demo)
В	Crowther, Stephen:	98–101
Beamish/Roehampton Institute	Evening in Venice 32	fixatives 15, 23
of Art 10	Cullen, Patrick:	focus 30–1
Belfield, Claire: Pinecones 90	Tuscan Farmhouses 89	form 44–5
Bowen, Keith: Shearing Sheep 7	demo 86–9	demos $46-9$, $50-3$
brush drawing 20	Cuthbert, David 27	gallery 54–5
brushes 20	Cuthbert, Roz: Deckchair 43	format 30
		Fowler, Sue:
C	D	Standing Figure 54
card 12	Dawson, Doug 121	
Carpanini, David: The Graig 33	Denvir, Catherine:	G
Carpenter, Pip:	Seaside 107	gouache:
Field with Poppies 97	depth: creating sense of 43, 95, 96	removing ink with 19
demo 94–7	design:	to obliterate marks 25
carré pastels 8, 15, 22	two- and three-dimensions 32–3	graphite 16
blending 47	demos 34–7, 38–41	depicting pattern and textur
depicting pattern and texture	gallery 42–3	in 80
in 80	distance 28	erasing 14, 16–17
erasing 14	dot shading 19	still life (demo) 34–7
softening 47	drawing 26–31	grays: mixing 79
townscape (demo) 46–9	for washes 110	Gwynn, Kate 121
charcoal 7–8, 14–15	Dubery, Fred 26	
depicting pattern and texture	The Dairy 66	Н
in 80	Jardiniere 8	hatching 68
erasing 14	dusty media: fixing 15	Hersey, Nick <i>22</i> , <i>29</i>
townscape (demo) 38–41		Moira 53
Clarke, Colin: Istanbul 79	E	demo 50–3
Clinch, Moira 16, 105, 120	Elliot, John 104	highlights 40, 67, 113

Elsbury, Gill 10

tonal values 56

27

Hobbs, James:	Marsh, Gaynor: <i>Protea 91</i>	figures in pen and wash (demo)
Covered Market 41	materials 11–25	98–101
demo 38–41	medium: selecting 7–8	still life (demo) 58–61
Hodgion, Gay: Dolly 103	Melegari, Carl: Street Walking 102	pencils 8, 16
Trouglon, Gay. Bony 105	Millichip, Paul:	aquarelle 24–5
1	Conch Shell 45	still life (demo) 70–3
inks 19	Punna Tree 81	charcoal 15
color mixing 68–9	Moore, Elizabeth: Dancer 93	colored 24
erasing 19	movement 92–3	mixing 68
crasing to	demos 94–7, 98–101	erasing 16–17
I	gallery 102–3	holding 16
Joubinaux, Julie 18, 19, 26, 80	multiple-point perspective 33	landscape (demo) 62–5
Children at Play 92		Pendleton, Pat: Betsy's Retreat 69
Corncob 61	Ν	perspective 39, 42
demo 58–61	negative shapes 45	atmospheric 57
Playtime 101		demo 38–41
demo 98–101	0	in interiors 66
Two Shells 45	observation 6–7	multiple-point 33
	Ohsten, Kay: Cathedral Doorway 32	organizing 46
K	oil bars 22	of rounded objects 110
Kay, Sidney: Sheep at Croftnuisk 1	oil pastels 22	single-point 32–3
Kirk, Richard	portrait (demo) 74–7	vertical 32–3
Blue and Gold 125	overlaying color 68	planning 26–31
demo 120–5		portrait format 30
kneaded eraser 14	Р	portrait:
	paper 12–13	developing a style (demos)
L	stretching 21	120-5
landscape:	pastels 8, 22–3	in oil pastel (demo) 74–7
in pastel (demos) 86–9, 94–7	depicting pattern and texture	sitting for 120
in pencil (demo) 62–5	in 80	in wash (demo) 50–3
landscape format 30	fixing 22, 23	protuberance: creating 35
Lidzey, John: Interior Light 106	landscape (demos) $86-9$, $94-7$	
light: revealing form 55	mixing 22–3, 68	R
line 92–3	oil 22	Raynes, Jody
	portrait (demo) 74–7	Kitchen Table 113
M	still life (demo) 82–5	demo 108–13
McFarlane, Debra 13, 25	pattern 80–1	recession:
Memento Mori 85	demos $82-5, 86-9$	color properties 118
demo 82–5	gallery 90–1	creating 35
Seated Girl 77	pen and ink 8, 18–19	Ribbons, Ian 11, 27, 120
demo 74–7	depicting pattern and texture	Colonnade 42
Macleod, Audrey 104	in 80	Violinist 2

tone 56-7

demo 58-61, 62-5

S	gallery 66–7	
Sanford, Piers: Ranunculus 78	test strips 56	
shadows 44, 54, 55	tools 11–25	
tonal values 56	townscape:	
single-point perspective 33	in carré (demo) 46–9	
size 28–9	in charcoal (demo) 38-41	
Skeaping, John: Greyhound 93	developing a style (demos)	
sketchbooks 13	114–19	
solidity: conveying 32, 112	transparency 113	
space 44–5	two-dimensional design 32–3	
color properties 118		
demos 46–9, 50–3	V	
gallery 54–5	vanishing points 33	
still life:	vertical perspective 32–3	
in aquarelle pencils (demo) 70–3	viewfinder 28	
arranging 29	viewpoint 28	
developing a style (demos)		
108–13	W	
in graphite (demo) 34–7	Wallis, Kitty: Hot Tub No.11 69	
in pastel (demo) 82–5	washes 20	
in pen and ink (demo) 58–61	color mixing 68–9	
stippling 19	drawing for 110	
Strand, Sally: Men in White 107	drawing over 25	
stretching paper 21	figures in pen and wash (demo)	
stump: using 17	98-101	
style:	over dry colors 24	
developing 104–7	portrait (demo) 50–3	
demos 108–13, 114–19, 120–5	Wiffen, Valerie	
	Architect's Grandchild 125	
Т	demo 120–5	
Tarbet, Urania Christy 11	Autumn Sun 119	
Taylor, Martin:	demo 114–9	
San Vittore, Toscana 65	Home Cooking 113	
demo 62–5	demo 108–13	
texture 80–1	A Loaf of Bread 56	
demos $82-5$, $86-9$	Wilson, Susan: Cosima 106	
gallery 90–1	wood 12	
three-dimensional design 32–3	Woods, Michael:	
demos 34–7, 38–41	A Bunch of Keys 67	
gallery 42–3	Dragon Hall Door 55	
in interior scenes 66	Dried Flowers in a Basket 81	

Tent 44

Credits

Quarto would like to acknowledge and thank the following artists for taking part in the step-by-step demonstrations, and for providing artworks and photographs used in this book.

Pip Carpenter: pages 94-7 Moira Clinch: pages 16, 28, 120 (middle) Tony Coombs: pages 114, 115 (all except top right), 116–19 (bottom row) Patrick Cullen: pages 86-9 Doug Dawson: page 121 (bottom left) Ian Fellows: pages 30-1, 34-7, 46-9, 70-3 Kate Gwynn: page 121 (top left) Nick Hersey: pages 22, 29, 50-3 James Hobbs: pages 38-41 Julie Joubinaux: pages 18-19, 80, 58-61, 98-101 Richard Kirk: pages 121 (bottom right), 122-5 (bottom row) Debra McFarlane: pages 13, 25, 74-7, 82-5 Jody Raynes: pages 108, 109 (all except bottom right), 110–113 (top row) Ian Ribbons: page 120 (bottom) Martin Taylor: pages 62-5 Valerie Wiffen: pages 109 (bottom right), 110-13 (bottom row), 115 (top right), 116-19 (top row), 120 (top), 121 (top right), 122-5 (top row)

All other artists have been credited on the page where their artworks appear. While we have made every effort to acknowledge artists and copyright holders, Quarto would like to apologize should there have been any omissions or errors.

Quarto would especially like to thank Ian Kearey and James Hobbs for their invaluable assistance in completing this project, and Valerie Wiffen for supplying some of the materials and equipment used in photography.